Benedict J. Fernandez

Benedict J. Fernandez

Benedict J. Fernandez
Protest
Photographs 1963 – 1995

Edited by Brigitte Buberl

Texts by Brigitte Buberl, Christiane Gehner, Fritz L. Gruber, Klaus Harpprecht,
Gerald Koeniger, Ellen Maurer and Karl Steinorth

EDITION STEMMLE

Contents

6 # Preface

**Brigitte Buberl and
Wolfgang E. Weick**

As the photographer of the exhibit "I AM A MAN"
I invite you to view my vision for the past four
decades. You will see my journey over the years,
passing through a variety of experiences.
My images are manifestations of the conflicts, rewards,
happiness and sadness of these periods.
I would like to share these with you so that you might
enjoy that journey as I have.

Ben Fernandez

Applied to the photographer Benedict Joseph Fernandez, the exhibition title *I AM A MAN* suggests a number of different meanings. As a political slogan – coined by Martin Luther King in his appeal for the recognition of the dignity of all men, regardless of race, color or creed – it had real meaning for the photographer of Puerto Rican-Spanish-Italian descent and provided him with a goal worth fighting for. At the same time, the word *MAN* stands for itself and the *machismo* Fernandez consciously accepts, although he tempers it continually with tongue-in-cheek self-assessment and critical studies of *machismo* as a crude phenomenon apparent in all areas of human life. Nonetheless, *machismo,* in his view, is also the expression of a man's natural, proud self-image. And finally, *MAN*, emphatically understood as "the human being," is also a major focus of his work. Nothing that is human, so it appears, is unfamiliar to Fernandez, who consistently invokes his life's experience and uses it as a basis for argument.

Although Gerald Koeniger has tried to pin him down in his interview, Ben Fernandez cannot be categorized in political terms. He rejects labels such as "left" or "right" as too simple, too one-dimensional. Although all of his photographs have immediate social relevance, he does not intend for them to teach, to offer didactic demonstrations or even to serve as reminders. As Fernandez looks at the world, so may the viewer experience his photographs – pictures of a multifaceted world taken at particular moments, which can be read as timeless allegories. While they bear witness to the now legendary revolutionary decade of the Sixties, their gaze is focused upon the individual. Thus in his photos of demonstrations it is not the masses that are of importance, but the single human being, his actions, his face, his anger or his joy. Overall, they present an honest – and therefore in places ugly – picture of the United States. This clearly locates him within the trends of the Sixties, when young rebels, artists and students broke with the falsely painted pathos of official America. In the demonstration photos in particular, it is the National Guard, the forces of order, who seem threatening, who appear to have caused the destruction and chaos that surround them. But there is also the Ben Fernandez who takes a positive, at times loving approach as well, one that allows him to render views of people waiting at a railroad station as still lifes, for example. His working methods produce pictures that appear to have no borders. They capture the viewer, involving him, as it were, in the events. The photographer's gaze is participatory, never voyeuristic.

Ben Fernandez first came to Dortmund twelve years ago. He was always so deeply involved with teaching, however, that his stays produced no photographs. The pictures he brought along of an unfamiliar world were so impressive that museum executives soon decided to present them to the public. Featuring photographs from different cycles, the exhibition offers a representative selection but does not attempt to provide a comprehensive survey of three decades of creative work. Ben Fernandez has always been much too curious and energetic a photographer to be content to deal with no more than the eleven themes presented here. He describes himself as an anthropologist rather than a photographer, and his photos confirm the dictionary definition of that discipline: "...[The study] of the origins, development and differentiation of the human species, of the various forms of behavior employed by humans in coping with the equally varied manifestations of their environment and ultimately of the position of the human being in history and the world."

About
Ben Fernandez

Fritz L. Gruber

Ben Fernandez emerges from the period of intensified creative photography that began in New York and has radiated into international art over the past few decades. To a great extent, his path to photography was prepared by the legendary Alexey Brodovitch (1898–1971), who helped propel many others, including the major portraitists and fashion photographers Richard Avedon and Irving Penn, on their way to successful careers. Brodovitch was Ben Fernandez's most important mentor and promoter, a man who not only gave him difficult photographic projects to carry out but awakened his talents as a teacher as well.

We now know Fernandez as a master of the camera. One could list a great number of subjects he has approached from the standpoint of a concerned observer. They would span the globe, from the U.S. to Europe and on to Japan and China; they would also include people, individuals and groups, in his own country and simple, almost archaic still lifes. Any attempt to assign him to one of the standard pigeon-holes of photographic art is doomed to failure. He describes a situation or an event in his very own unique, penetrating way, but with an unwavering commitment to the human being. His visual statement often rises to the status of a symbol, and thus a picture is created as a concentrate of several others.

Fernandez's visual stories offer insights into particular spheres of humanity or geography – the macho world of the *Bikers,* for example, who identify with the power of their motorcycles, or the bullfighters, who pretend superiority over their victims. In Puerto Rico he sees both the elegance of the boulevards and the convicts behind bars. In London he is interested in the speakers in Hyde Park, with their bowler hats, and in the Bobbies in their towering helmets and chinstraps. In Bonn he is impressed with the characteristic gestures exchanged by Willy Brandt and Helmut Schmidt. Wherever he goes, he sees the old, the passing culture in its striving for modernity. In Moscow, his gaze focuses upon the *Soldateska* rising out of the past and the future-oriented scenery of the new do-nothings. The clash between historical tradition and progressive civilization in Japan concerns him as well, and all the more so in China, where yesterday grapples with tomorrow.

Back in America, he shows us bizarre performances of female self-exposure. He is always offering something that – despite the brevity of the exposure itself – goes beyond the moment at hand to become a lasting image. He even gives meaning to *pars-pro-toto* industrial parts. His *grande œuvre,* the stations in the life of Martin Luther King (1929–1968), bears witness to his personal concern with the work of the great Black leader, his death and its aftermath – an illustrated biography that moves the reader to sympathy and contemplation.

It is not mere curiosity but instead his desire to express himself and to communicate insights that drives the photographer Ben Fernandez and his selected points of view out into familiar and unfamiliar worlds. His command of his medium is so complete that his photographs require no further commentary. They are forceful documents of an extraordinary personality.

And when, with the suddenness and energy of a hurricane, the man himself appears from time to time, we are fully captivated by his personality. This overpowering figure is a fountain of knowledge, experience – and *suada.* Ben Fernandez is a monument to an entire photographic era that profits from the past and looks towards the future. Photography, whose death knell may *seem* to have been rung by electronic technology, is neither *passé* nor lost as long as artists like Ben Fernandez still use the traditional camera to say what they have to say.

An American Tradition
The Camera as a Weapon

Karl Steinorth

As early as 1968, with the publication in New York of his book entitled *In Opposition*[1], from which a number of photographs have been reproduced in this catalogue, Benedict J. Fernandez documents the confrontation between highly vocal minorities and the "quiet majority." Here was a new phenomenon, even for late-1960s America: the confrontation with minorities who saw it as a part of their constitutional right to free speech that the public would also listen to their views. Many of Benedict J. Fernandez's photographs contributed significantly to public awareness about this form of opposition.

His photos place him firmly within the tradition of famous American photographers who used the photograph as a means of documenting both deplorable political and social conditions and efforts to eliminate them. Although the concept originated in England, the finest examples of this kind of photography have come from the United States.

The development of photo-mechanical printing processes made it possible to make a broader public aware of such conflicts and abuses for the first time. One example, featuring printed photos in the cumbersome form of glued-on woodburytypes, is the 1877 serial work *Streetlife in London*[2] by the Scottish photographer John Thomson. This series was intended to awaken the interest and sympathy of the middle class for the poor. Proof that photos possess a much stronger visual power than drawings made from photographs may be found in a comparison between Thomson's *Streetlife* and the pioneer work in this field, that of Henry Mayhew, who in the late 1850s published *London Labour and London Poor*[3], a book of drawings prepared from daguerreotypes made especially for the occasion.

The belief that the chance of bringing about change can be improved if the public is confronted with miseries and abuses in a gripping way gave photography a particular importance. The following report appears in the *Photographische Rundschau* of 1894 under the title "Photographs of the living quarters of the poor and miserable in America"[4]:

[1] *In Opposition, Images of American Dissent in the Sixties,* by Benedict J. Fernandez, Preface by Aryeh Neier (New York: 1968).
[2] John Thomson, *Streetlife in London* (London: 1877; Reprint Dortmund: Edition Harenberg).
[3] Henry Mayhew, *London Labour and London Poor* (London: 1858).
[4] *Photographische Rundschau,* No. 7 (1894) p. 225.

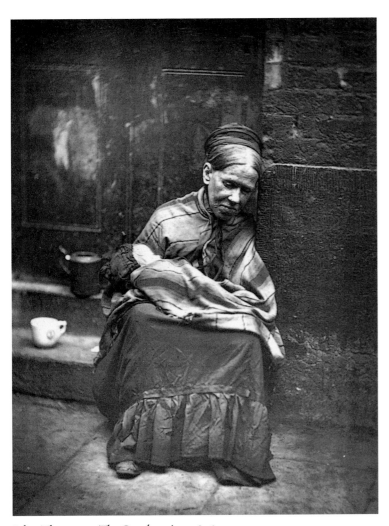

John Thomson, *The Crawlers*, circa 1876–77

recognized intervention as its moral obligation. Inseparably connected with this kind of photography are the names Jacob A. Riis and Lewis W. Hine. As Peter Pollack writes: "Like Voltaire's broadsides, the photographs of Jacob A. Riis (1849–1914) were instrumental in putting a revolution in motion. This uprising began in New York in 1887; its targets were the slums, in which people were wasting away, and the corrupt regime that tolerated this misery. Riis was a police reporter at the time. He wrote persuasively, but it was his camera that made his reports into irresistibly potent weapons."[5] Riis, a Danish carpenter who had immigrated to the U.S. at the age of twenty, knew about the people who lived on the dark side of life. In 1890 he wrote a book about his observations bearing the title *How the Other Half Lives*[6]. Riis collected written and photographic evidence on the deplorable conditions and, as a journalist, used both the pen and the camera to bring about pioneer reforms. As a result of his tireless efforts, derelict houses were razed and domiciles suitable for human habitation were built for the homeless.

The history of photography names Riis and Lewis W. Hine in the same breath. Hine, born in Wisconsin in 1866, studied sociology in Chicago and New York and became a teacher of geography at the private Ethical Culture School in New York in 1901. Having been asked to teach photography, he turned to this medium in 1903. In his free time he visited the impoverished

11

"According to reports appearing in the *Globe*, a Chicago minister has collected funds for the purpose of having photographs taken of the filthiest and most run-down parts of the city, particularly the most dilapidated and squalid barracks, 'flophouses' and other such buildings, of which Chicago is full, and, if possible, of their inhabitants as well. The purpose of this undertaking is to show the rich and prosperous the misery and hopelessness in which their poorest brethren live. These photographs are to be hung in churches, libraries, lecture and concert halls and everywhere the public gathers in large numbers."

Public willingness to accept reform provided the foundation for a socially committed photography that

Jacob A. Riis, *Life in the Cellar*, circa 1890

5 Quoted and translated from Peter Pollak, *Welt der Fotografie* (Düsseldorf: 1962) p. 294.

6 Jacob A. Riis, *How the Other Half Lives* (New York: 1890), Reprint (Dover, New York: 1971).

immigrants on Ellis Island. "I wanted to show things that needed to be changed and those that needed to be praised," he wrote. With his camera, he recorded the arrivals of immigrants in the tenements of New York. Of his work Beaumont Newhall writes: "Hine realized, as Riis had before him, that his photographs were subjective and, for that very reason, were powerful and readily grasped criticisms of the impact of an economic system on the lives of underprivileged and exploited classes."[7] In 1908 Hine gave up teaching and became a professional photographer. In 1911 he was commissioned to by the U.S. Committee on Child Labor as a photographer. His descriptions of the exploitation of children eventually led to the passage of child labor laws.

Perhaps the greatest example of how photographs can be used as an effective tool for social commentary and social change is the photo-documentation on the status of American agriculture and the situation of American farmers put together during the years 1935–1943. During this period, a group of about twenty photographers, of whom no more than six were ever active at the same time, took more than 270,000 photographs. The sheer number of photographs, all taken for a single purpose, is suggestive of the significance of this undertaking. The fact that many of the most important photographers of our century participated in this project makes it truly unique indeed. In 1939 Edward Steichen assessed the accomplishments of the photographers involved in the project as follows: "They also found time to produce a series of the most remarkable human documents that were ever rendered in pictures."[8]

The economic catastrophe brought on by the Depression affected rural America with particular force as natural calamities shook these regions at the same time: drought and dust storms followed on the heels of the collapse of the market for agricultural products. 1930s America was characterized by long lines of jobless people waiting outside soup kitchens, by farm workers driven from their now infertile lands by the dust storms, and by the misery to which itinerant workers were subjected by unscrupulous employers. President Roosevelt

was forced to recognize that "a third of the population lives in slums, undernourished and poorly clothed."[9] He established new government agencies for the purpose of improving the lot of those most severely affected. One of these new agencies was the Farm Security Administration, known as FSA, whose task it was to revive the stricken agricultural economy. The FSA provided low-interest loans and government subsidies. A program of this kind was naturally quite expensive and correspondingly controversial. In order to document both the full extent of the problem and the effectiveness of government aid, the FSA decided to make use of photography. Roy Emerson Stryker was appointed Chief of the Historical Section.

As a member of the faculty of the economics department at Columbia University, Stryker had always used excursions and photos to show his students the reality that lay behind the statistical tables and textbook descriptions. This background equipped him better than anyone else for the task of initiating a project devoted to the documentation of social conditions using photography. He gave his staff photographers precise instructions from the very beginning, describing each assignment in detail and explaining what was to be photographed and why. He required every photographer to become acquainted with the region to which he was sent, with the people, the economic situation and the social and political customs. The pictures that resulted were so interesting that they were printed by numerous newspapers, thus showing Americans living in better circumstances just how badly a third of the American population was suffering.

The first staff photographer hired by Roy Stryker was Arthur Rothstein. In the spring of 1936 Rothstein went out on his first extensive photo assignment, a journey that took him into parts of Oklahoma severely impacted by the dust storms that had made many farmers homeless. Here he made his famous photo showing a father trekking with his two small sons through a dust storm. By the time Rothstein left the FSA in 1940 to become an editor on the staff of *Look*, he had seen more of the United States than any other FSA photographer.

The FSA photographer whose pictures probably enjoyed the widest distribution was Dorothea Lange. Having studied photography under Clarence White at Columbia University in New York, Dorothea Lange opened her own portrait studio in San Francisco. In 1932

[7] Beaumont Newhall, *The History of Photography,* 5th ed., 3rd printing (New York: 1988) p. 235.

[8] Edward Steichen, "The F.S.A. Photographers" in *US Camera,* Annual 1939 (New York: 1938) pp. 44.

[9] Quoted and translated from R. J. Doherty, *Sozialdokumentarische Photographie in den USA* (Lucerne: 1974) pp. 15.

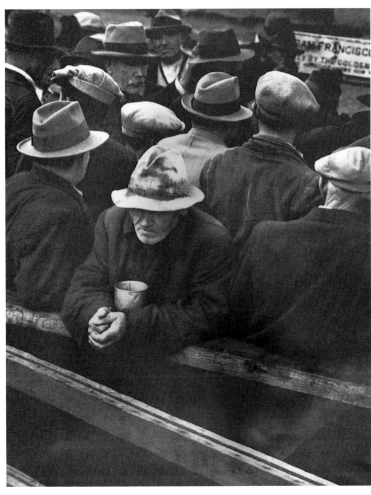

Dorothea Lange, *Soup Kitchen,* California, 1933

largely responsible for establishing simplicity and immediacy as prominent characteristics of FSA style in documentary photographs. It has been said of Walker Evans, and rightly so, that he made the immediate appear timeless and the particular general. Other FSA photographers who eventually became prominent American photojournalists include Russell Lee, Marion Post-Wolcott, John Vachan, John Collier and Gordon Parks.

If we wonder today why photographs were – and to a large extent still are – so effective as documents of social and political phenomena, we should consider the power of the photo, as a medium of visual communication, to generate immediate and for the most part emotional or sensual understanding. Moreover, the photograph is still regarded as a reliable piece of evidence, unlike other documents produced by people in writing or drawing, in which we are more likely to recognize the influence of the reporter's subjective

she was so moved by the misery of the unemployed that she left her studio as often as possible to take photographs of the men in the streets. An exhibition of her pictures prompted Roy Stryker to ask Dorothea Lange to come to work for the FSA. Dorothea Lange had the rare ability to capture vividly the human victims of the Depression on film. Her extremely moving photos achieve their effect not through tricks or unusual techniques, but through the profound sympathy for her subjects that is evident in all of her pictures. After America's entry into World War II she went to the camps established by the U.S. government for the internment of young Americans of Japanese descent. Her photos were instrumental in mobilizing public opinion in favor of offering compensation for the injustice inflicted upon these American citizens.

Other FSA photographers included Carl Mydans, who later became a photographer for *Life,* and Walker Evans, the most influential of all FSA photographers in terms of photographic art. Among other things, he was

Dorothea Lange, *Demonstration,* San Francisco, 1933

Walker Evans, *Southeast,* 1935

views. We now know, of course, that even documentary photography is not objective, for the selection of motif and detail alone make the photograph subjective in its statement. And especially in the age of digital image processing the public's willingness to accept photos as reliable documentary evidence is rapidly diminishing. Nevertheless, no other medium is capable of depicting social and political conditions quite like photography. Lewis Hine expressed this view in the following way: "If I could tell the story in words, I wouldn't need to lug a camera." [10]

The legacy of such great photographers as Jacob Riis, Lewis Hine, Margaret Bourke-White and all of those who worked for the FSA was taken up after the end of World War II by a number of fine photojournalists. Noteworthy among them are names such as Douglas David Duncan, Eugene Smith, Lee Miller, Mary Ellen Mark, James Nachtwey and the Turnley brothers. Ben Fernandez and his photos are also firmly grounded in this tradition. Many of his photographs are documents, if not in fact symbols, of the political struggle in the United States against the war in Vietnam and for the non-violent achievement of equal rights that is so closely connected with the name of Martin Luther King. Many of Ben Fernandez's photos prove that photography, despite all claims to the contrary, has indeed lost nothing of its power to report facts in an immediate and effective way. Margaret Bourke-White

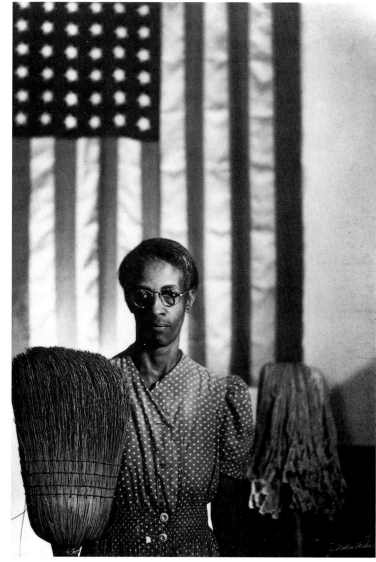

Gordon Parks, *American Gothic,* Washington, D.C., 1942

titled her book of photographs about the plight of cotton-pickers in the American South *You have seen their Faces* [11]. It is a title one could, I think, also paraphrase in other words: "You can no longer ignore what you have actually seen," and just such a title would be particularly appropriate to the photographs of Ben Fernandez.

[10] Judith Mara Gutman, *Lewis W. Hine 1874–1940* (New York: 1974) p. 17.
[11] Margaret Bourke-White, *You have seen their Faces* (New York: 1937).

14

The Revolution Took Place in America:

Impressions of the Sixties

Klaus Harpprecht

Sometimes an entire epoch is summarized in a face. With a quiet, almost cool gaze, Martin Luther King looked down at the crowd that had begun to gather at the church on 16th Street in Birmingham, Alabama since the early morning hours. The church itself was a massive structure, presumably built during the first few decades of this century. While Dr. King's powerful sermon had stirred every single soul in this militant parish, it had not released his listeners from the mandate of discipline for a moment.

It was the language of the Bible and that of his father, the preacher from Atlanta, as well. During his childhood it had given him – and millions of his fellow African Americans – access to a world in which the spirit took flight above the depressing sphere of the everyday. It had illuminated the word, translating it into music and filling hearts with a glimmer of hope, at least on Sundays, when they went to worship. Martin Luther King's mastery of the preacher's rhetoric was comparable to Albert Schweitzer's command of the organ. Towering phrases rose up in majestic rhythms. When he lowered his voice, certain sentences became sheer poetry. Though he spoke freely, not a single word escaped his control.

This 20th century has known its share of orators with the talents of genius, their magic derived from a variety of different and often quite singular means. Those of us somewhat older can still hear the barking staccato of the People's Tribune [Hitler] from Braunau on the Inn, with its astonishing power to whip up the emotions of a crowd. Or the sweltering, shimmering pathos of Goebbels, the great propagandist from the Rhine; the Caesarian oratory of the Neo-Roman speaker Mussolini; Winston Churchill's hypnotic stutter, which did not prevent him from bringing the richness of the English language to full bloom in a manner expected only of poets; the clarion melody of Charles de Gaulle; Franklin Delano Roosevelt's soft and seductively optimistic tenor. Measured against them all, however, Martin Luther King was probably the most talented speaker of our century.

His voice became soft and low when he told the members of the parish to go forth, led by God, strengthened by the understanding of the necessity for suffering and protected by the steadfastness of their faith. He called out to them, saying that they must never, not even in a brief second of weakness, allow themselves

to be maneuvered into responding to violence with violence. This he said again and again: only through a renunciation of violence and an unshakable commitment to peace would they be rewarded one glorious day with the triumph of justice.

He knew full well that the heavily armed cohorts of Bull Connor, Birmingham's police chief, awaited them outside the church. One out of every two or three of these men held a trained police dog on a leash.

The first fifty people went outside. Those who remained inside the church folded their hands and began to sing "We shall overcome … ," the hymn of the Civil Rights movement. A few moments later the next group left the church. "Now you go – and go with God," said Reverend King. Wave upon wave, they moved towards Connor's thugs. Soon there were no more handcuffs. No one attempted to defend himself. There were no cries of protest, no screaming voices, no resistance, no incidents. Nothing was heard but the yells of the police and the barks of their dogs. When they, too, became quiet, a ghostly silence fell over the scene.

It was the armed men, and not their victims, who gave bystanders the impression of disheartened helplessness, as if they already suspected that the power of these weak people and the march of history would ultimately defeat them. Even their threats against witnesses – a handful of reporters from Washington and New York and a German TV camera team – were of no avail. Those arrested were loaded onto trucks – men and women, old and young, some of them barely more than children - and interned in a provisional detention camp outside the city limits.

Martin Luther King remained standing at the altar, maintaining his impenetrable composure. Not a single movement, no flicker of his eyes and no change in his voice betrayed the burden of tension he carried. He took time for a brief interview: Ours were the only cameras present in the church and in the square outside, and he knew how important they were. In my notebook I jotted down the words: "cold power of the prophet."

He was the last to enter the square, accompanied by several of his adjutants – among them Andrew Young, who fifteen years later was to become President Carter's ambassador to the United Nations. The arrest was a moment of silent triumph. King was quite aware that the humiliation suffered by his thousands of followers was in fact the revelation of a battle won. He knew that the

pictures of the barking dogs, held at bay by policemen with beer bellies bulging over their belts and holsters, would be seen around the world. He knew that the attention of the press and the federal authorities in Washington would bring about the release of himself and his parishioners. And he must have known as well, even then, that his unwavering commitment to non-violence would one day lead to his own martyrdom.

Two full years later the revolution of passive resistance achieved its first great objective in the passage of Lyndon Johnson's civil rights legislation, one hundred years after the Emancipation Proclamation. Surely, the decisive phase in the march towards equality began with the death of John F. Kennedy, this charismatic and ambitious man from a rich New England Irish family, the first (and thus far the only) Catholic to occupy the White House.

Because of his brilliance and his charm, Kennedy was worshipped among all peoples of the world as a symbol of progress, of a renaissance of enlightenment. This may have been a misconception, but it was a fortunate and, all in all, a useful one. On the bitter cold winter's day of his inauguration in front of the Capitol, the poet Robert Frost set out to proclaim the beginning of a new Augustan era to the crowd gathered for the festivities. The sun blinded the old poet, whose face appeared as a great furrowed landscape of wrinkles. The light prevented him from reading the overenthusiastic hymn he had prepared for the occasion, leaving him with no choice but to recite a poem he knew by heart. The young president, his elegant wife and the contented audience helped him with encouraging smiles to overcome this little embarrassment. Was it an omen? No one took notice at the time.

Kennedy's willingness to examine untested ideas and consider efforts towards reform were in themselves enough to fuel hate in the dull consciousness of the western and southern *petit bourgeois.* They recognized a threat to the only privilege they could truly call their own: the superiority of whites under the law. The decisiveness with which Kennedy, after a moment of weakness, responded to Nikita Chrushchev's brutal strategy of coercion as expressed in the stationing of missiles in Cuba gave him a moment of respite. But no more. While he cautiously and hesitantly declared his willingness to undertake a number of reforms, the opposition reacted as if he were in the process of inval-

idating all traditional American values at once. In reality, John F. Kennedy was not a "liberal" president at all, in the American sense of the word, and certainly not a "left-winger". He was rather a moderate conservative who knew how to read the signs of the times, a man insistently encouraged by his younger brother Robert, head of the Justice Department and himself a bundle of energy driven by great courage and clear perceptions, to recognize the need for change.

Doubts regarding the direction of change had been swept away with the Supreme Court's decision ordering the first school integration in Little Rock, Arkansas and President Eisenhower's dispatch of the National Guard to ensure enforcement of the law. Not long after Kennedy's inauguration, our camera team was present as the first Black children – three or four little girls, fear making their faces appear more green than dark – were escorted through a jeering crowd of whites by police and FBI agents to a school ordered by the court to integrate. Two decades later, New Orleans elected its first Black mayor.

During the Kennedy administration, comprehensive legislation designed to guarantee Black citizens the same rights as those of the white majority was still many years away. Preparatory reform initiatives were under consideration. More could apparently not have been hoped for at the time, certainly not before the elections scheduled for November 1964. Victory for the Democrats and their president was by no means certain. Texas was seen as a key state, one that Kennedy had to win in order to be re-elected. The trip to Dallas was to be the first event in a carefully planned campaign offensive. Washington awaited a visit by Ludwig Erhard, Chancellor Adenauer's successor. Despite the president's triumphant journey through Germany, during which the enthusiasm of our people seemed on the verge of spilling over into hysteria from time to time, particularly in Berlin, the gap of mistrust that existed between the old man from Rhöndorf [Adenauer] and the elegant young American head of state had never been breached. With his rosy, naive optimism, Professor Erhard, referred to by a colleague in well-meaning derision as the "Bundesmutti" (Germany's little mother), appeared to have a better chance of gaining favor in Washington than the old Chancellor.

I was sitting at the editing table of our little rented studio in one of Georgetown's old, narrow streets putting together a short film about the preparations for the Chancellor's visit. At about two o'clock the program on the radio playing in the background was interrupted by a report on the assassination in Dallas. I leaped to the telephone and managed to get in a report and short commentary for the evening news before the lines were disconnected. The effects of the shattering events felt in even the most remote corners of the world in those hours apparently took their toll on my own voice as well.

Not long before, during the Cuban missile crisis, the shadow of impending nuclear war had been cast over all of the continents. Those in power in Moscow and Washington seemed to have learned their alarming lesson. They agreed to initial measures intended to reduce the danger – the hesitant beginning of a campaign of disarmament diplomacy which reached its finale twenty-five years later in the collapse of the Soviet military bloc and the dissolution of its eastern empire, events that not even the boldest of political thinkers would have dared to predict at the time.

Was the assassination of the president a blow struck against peace? Who directed it? Moscow? The humiliated dictator in Havana? Or was the deed motivated by matters of domestic politics? Was it a Mafia job? An extreme-rightist conspiracy? A mentally ill loner? No one knew. I suspected a domestic American drama. Whatever the explanation was, we were thoroughly convinced that Kennedy's death would have a lasting effect upon the history of our century.

This proved to be true, in an indirect way. Foreign policy constellations showed no indication of changing for the time being. Lyndon B. Johnson, Kennedy's Texan successor, promised partners in East and West a continuation of the current course. Still under the influence of the shock, he could hardly have realized that assassin Lee Harvey Oswald, a confused young man, had paved the way for the most decisive reforms of the period.

Johnson had never hesitated to let the intellectual and social elite that had formed itself around Kennedy know that the Vice-President of the United States – only a heartbeat away from power, as was remarked with appropriate realism – was condemned to live a dog's life. He was privileged to take on only a few miserable little tasks of no interest to the president – crumbs from his master's table. He participated only

marginally in the major decision-making processes, and only in cases where his network of relationships on the "hill" needed to be activated in order to secure a majority in Congress for legislation proposed by his chief.

No one knew Capitol Hill, its cliques and alliances, its rationale and its quirks, better than Lyndon Johnson. The former Senate majority leader was a master of the art of manipulation, both subtle and brutal. Over the long decades he had fought and worked his way up from a position as the assistant of a rich Texan politician to become a member of the first echelon of Washington insiders – constantly pursued by doubts based on his working-class origins in the rural South. His only semi-intensive encounter with the world of culture amounted to a few semesters at the hardly prestigious teachers' college in San Marcos. He came into money through an advantageous marriage and especially through the exploitation of his connections in the capital, yet his prosperity paled in comparison with the immense Kennedy fortune.

His experience in Congress and his cunning pragmatism counted for little among the well-educated and arrogant White House "eggheads." Kennedy's advisors found his down-home manners amusing and his vulgarity contemptible. But now that Kennedy, the glorious hero, had fallen victim to the gunshots of an insignificant vagabond, Johnson was finally in a position to show these "snobs" the meaning of political efficiency. Congress, like the country at large, would still feel the effects of the shock for many years and now, in a state of near paralysis, was prepared to submit to the overpowering will of Kennedy's successor. Within a very short period of time Johnson pushed through a package of reforms that Kennedy could hardly even have proposed without encountering unbending resistance. Equality for Black Americans was ensured through unambiguous laws, while immigration policy was trimmed of the worst of its arbitrariness and re-structured through the imposition of new quotas (permitting hundreds of thousands of Japanese, Chinese, Koreans and Filipinos entry into the U.S., to the benefit of the country). With his program for the "Great Society" the Texan president laid the cornerstone for an American welfare state (which, plagued by constant abuse, is now being aggressively dismantled by the new conservatives).

It can be said of Lyndon Johnson that his bold domestic policy earned him a place among the most important presidents of this century – despite the corruption and a depressing absence of style. But he failed nonetheless, because of his greedy quest for greatness, because of his obsessive ambition to surpass his predecessor's fame by waging a minor war, because of his lack of circumspection in world affairs. In a word, he failed because of Vietnam.

Eisenhower and Kennedy had left him a legacy of problems in Southeast Asia. Following the departure of the French from Indochina, communist North Vietnam had begun a war of attrition against the southern republic. American military advisors were dispatched to help reverse the chronic deterioration of the Saigon regime. Kennedy intensified the limited engagement which Eisenhower, a sober-minded general, had presumably expanded only with great caution.

According to the "domino theory" supported by whiz kids in the Pentagon and the State Department, one Asian country after another would fall under communist control if Ho Chi Minh's armies were allowed to overrun Saigon. Lyndon Johnson trusted the analyses provided by this elite, since referred to with a mixture of admiration and scorn in the book entitled *The Best and the Brightest.* He was only too happy to give in to the demands of Pentagon officials, who mobilized a powerful force to fight the war in the ricefields and jungles of Vietnam. America eventually committed as many as a half a million soldiers to the effort to stamp out the bush-war fire – in vain.

The student population, which represented only a minority in the drafted jungle army, quickly began to rebel against the campaign in Vietnam, viewing it as a colonialist war for which they were unwilling to sacrifice their lives. Tens of thousands of young men evaded the draft by fleeing to Canada, Mexico or neutral Sweden, which was not a member of NATO. Many of them did not return home from exile until ten years later, when Jimmy Carter, the reconciliation president, granted them amnesty. The growing resistance against the murderous mission in this far-away corner of Southeast Asia was more than simply a political protest. In actuality, it was nourished by a deep sense of alienation on the part of the younger generation with respect to what they regarded as the mummified institutions of the world of their parents, their society and their country.

The United States had been spared the immediate experience of the death of millions, the mass displacement, the destruction and the social devastation of World War II. It had emerged from the catastrophe as the only intact world power, although in the eyes of many of its citizens this role was unwelcome, and U.S. involvement in the Cold War and the thousands of international compromises a blatant contradiction of American idealist traditions. Radical instructors at America's universities combined the teachings of Marx and Lenin, a pinch of Nietzsche, a bit of feminism, dalliance with so-called sexual liberation and flirtation with drugs to form an explosive mixture. In provocative professorial sermons they called for revolt against "bourgeois conditions". The Californian pronouncements of the epoch have since been carried away on the wind – surely they were insubstantial enough. But at the same time the Civil Rights movement and the war in Vietnam provided the young with goals which left no one indifferent. The social condition of the Black minority demanded a clear (and by no means risk-free) commitment. The struggle against the war was a matter of life and death – not only on the battlefields of Vietnam, but ultimately, as the clash between students and the National Guard at Kent State University in 1970 so tragically demonstrated, at home and in the nation's schools.

The gravity of the conflict distinguished the American protest movement from the noisy demonstrations in Europe, which lost themselves in a peculiar lack of commitment – even after the May demonstrations of 1968, as Paris seemed destined to collapse in flames. The situation in the French capital appeared so serious that President Charles de Gaulle briefly considered the advisability of seeking protection from the army. However, the uprising proved to be no more than an overpowering high, not entirely free of its own operettic qualities, followed immediately by a sobering return to reality, when Parisian workers and the Communist party in particular made it clear that they wanted nothing to do with a rebellion of spoiled young people from the Sorbonne.

A look at Germany during this period might cause one to ask why the will to express moral outrage consistently appeared to grow stronger in proportion to the geographical distance from the location of conflict. Protesting students went to the barricades for Ho Chi Minh, for Khomeini's Iranian fundamentalists or for the leftist in Nicaragua. They hopped through the streets under banners bearing the images of "Uncle Ho" and Mao Tse Tung, clutching the little red book containing the words of Peking's communist czar in their hands, though one should have known at the time that he was a brutal dictator. Although no one suspected then that he would go down in history alongside Hitler and Stalin as one of the greatest criminals in the history of the world.

Rebellious students in the Federal Republic of Germany were generally indifferent to the regime of injustice that ruled the German Democratic Republic. They preferred to stake their claim to be the first to take anti-fascism seriously. In truth, they were merely acting out the miserable German farce of retroactive (and thus rather safe) resistance – much as late-blooming anti-communists are doing today – while terrorizing their professors, including particularly the liberals and social-democrats among them, in Nazi fashion. They became hopelessly involved in endless debates about theory, the inflammatory rhetoric of which soon enough failed to conceal their arrogance and lack of substance any longer. Anyone who attempts today to read the labyrinthine babblings of the unfortunate Rudi Dutschke, who eventually fell victim in those tumultuous days to the bullets of an adolescent right-wing extremist assassin, will give up, confused and exhausted, after no more than five minutes. The fanatical members of the Baader-Meinhof Group, on the other hand, went underground to wage their infantile war on society with gruesome resolve. It was not long, however, before the prominent figures of the movement took up the march – no, not *through,* but *into* the institutions, with differing degrees of success. Surprisingly, the lovable anti-authoritarian impulses of the early period were often cast by the wayside as power, responsibility and money suddenly appeared within grasp.

Not always, though, and – thank God – not totally. The tone that characterized communication between parents and children, perhaps between entire generations, in professional hierarchies and certainly between the sexes had become freer and more amiable. The somewhat vacillating, non-committal basic mood of a second youth movement remained. Elements of the "life reform" so eagerly sought after by young Germans during the periods before and after the First World

War experienced a kind of renaissance. At the same time, one witnessed the return to a fundamentally German love of nature and an almost mythical veneration of the forest. The public grew increasingly conscious of environmental issues; once hardly taken seriously, they had now become a part of the social credo. America, whose relationship to nature is less romantic (as it still often appears as a formidable enemy there), was far ahead of the Europeans in terms of ecology. Even more important was the direct political impact of the protest movement, which caused Lyndon Johnson to drop out of the race for a second term as president. Saddened and defeated, he eventually retreated to his Texas ranch. Robert Kennedy, who had announced his candidacy for the presidency with a call for a quick end to the war, died during the primary campaigns at the hand of a murderer precisely two months after the fatal shooting of Martin Luther King in Memphis, Tennessee. The death of the charismatic religious leader broke the spell of non-violence, signaling the beginning of the bloody and fiery riots in the Black ghettos of virtually every large city in America.

Hubert Humphrey, the liberal Vice-President from Minnesota, would probably have won the White House if the Democratic Convention in Chicago had not been overshadowed by the total confusion sparked by radical protesters. During those days I wrote my reports in a hotel room where my constant companion was the smell of tear gas. With its chaotic performance in Chicago, the protest movement, totally counter to its intentions, opened the door to the White House for Richard Nixon: the idol of the new conservatives and son of lower middle-class California, who had launched his career under the influence of the right-wing extremists surrounding Senator Joseph McCarthy; the anti-communist "witch-hunter" of the Fifties, who in his periods of alcohol-induced delusion so greatly intimidated liberal and left-wing intellectuals as well as the artist community, and whose campaigns swamped the bureaucracy in utter confusion.

In the fall of 1960 Richard Nixon had lost the election to Kennedy by the narrowest of margins. Now, in an ironic twist of fate, his hated enemies from the left virtually broke open the door to the White House for him. But history continued to pursue its zigzagging, dialectic course and to play out its game of paradoxes. For presumably only a conservative president could break through the previously unshakable taboos that had at least partially paralyzed American foreign policy. Following strategic principles proposed by his advisor Henry Kissinger, Richard Nixon dared to establish diplomatic relations with communist China.

No Democratic president could have undertaken the journey to Peking. The Republicans, however, used it to establish the basis for the eventual pull-out of troops from Vietnam, albeit only after an intensification of the war effort that took a horrible toll in victims. Moreover, Richard Nixon exploited China's enhanced status as a powerful lever to force Kremlin leaders into accepting the first treaties on nuclear disarmament and protection against the reciprocal threat posed by the presence of intercontinental ballistic missiles.

Lyndon Johnson, a great domestic president, failed because of foreign policy. In Richard Nixon's case the exact opposite was true. Having harvested triumphs abroad, he failed on the domestic front. Like Lyndon Johnson, Nixon became the victim of his own smoldering will to achieve "greatness." Unlike Johnson, however, Nixon exploited every possible means, including illegal ones, to guarantee his re-election. By breaking into Democratic Party headquarters at the Watergate, Nixon's zealous assistants planned – presumably with his approval – to gain access to strategic papers and compromising materials in the hands of the opposition. This amateurish and so miserably unsuccessful operation reminiscent of a third-rate Hollywood film, coupled with Nixon's helpless cover-up attempts, eventually left the president no alternative but to resign – as the first President of the United States to leave office in disgrace and humiliation. Consistently driven by the ambition to have his name written in the annals of American history, his wish had now been fulfilled in two ways: through his achievements and through his failure. Had it not been for the revolutionary spirit of the era, which had clearly left its mark in both the media and Congress itself, it is unlikely that the Senate and the House of Representatives would have found the strength and resolve needed to initiate impeachment proceedings against the president.

We can surely say of the Sixties in America that they were the womb from which nearly all subsequent developments of importance were born, developments that have in turn exercised a major influence on history as it approaches the end of a millennium: the crisis

in the American economy brought on by factors such as the financial burden of the war in Vietnam, investments in the arms race, excessive wage levels and the rapidly growing cost of supporting a welfare state; but also the economic renaissance resulting from the painful corrections that provided the basis for the rapid growth of the service society. The arms race spelled gradual, but inevitable ruin for the Soviet Union and its inflexible planned economy, ultimately causing its collapse and the end of the Cold War.

The Civil Rights movement, which gained legitimacy thanks to Lyndon Johnson's reform legislation in 1964, was probably the only truly successful revolution of the century. The evolution of the United States into a society in which all citizens share equal rights remains a source of astonishment to anyone who experienced the "old" America in the days of segregation. Unfortunately, equality under the law has not produced social peace – for a variety of reasons. The explosive potential of uncontrolled poverty is an ever-present and threatening fact of ghetto life.

The triumph of the Black minority and the successes of the feminist movement, both responses to historical necessity, naturally went hand in hand with a fragmentation of American society that now threatens to wear away the fabric of traditional institutions and structures of political authority. The unshakable domination of the majorities and – as a result – a revolt of the minorities have combined to weaken and jeopardize political systems in many parts of the world, the danger now appearing most acute in the Middle East and the Balkans. Both here and there the full authority of the United States – despite the weaknesses and inconsistencies of its leadership the only remaining functional world power – is required in order to prevent the spread of local fires. Europe, still mired in irresponsible diffidence with respect to its own unification, remained helplessly lethargic in its response to the growth of potentially murderous nationalist movements and the war at its very doorstep.

Benedict J. Fernandez:

On the Power of Photography and the Poetry of the Moment

Ellen Maurer

In his reflections on photography, Roland Barthes describes his attempt to write about a photo story on the topic of "emergencies." He fails because of his mistrust of mere objects, of the world of things. He finds nothing to say about these photos showing only white coats, stretchers and prostrate bodies. And he goes on to complain: "Oh, if there were only a single look to see, the look of an individual; if only someone in the photo would look at me! For photography has this power – albeit less and less, as the frontal view is generally considered old-fashioned – to look me right in the eye (…)"[1]

Perhaps it is precisely here that one finds the human side of the personal philosophy of Benedict J. Fernandez, who prefers to call himself a "photo-anthropologist" rather than a "photojournalist" and has dedicated himself to the study of human experience. He seeks the individual image, avoiding the anonymous voyeurism of the classical "street photographer" who, with the "energy of an invader" leaps into the masses in order to commit a series of robberies, "appearing out of the blue and disappearing just as suddenly again."[2] This is expressed with particular clarity in the series entitled *Protest,* consisting of a heterogeneous sequence of individual and group portraits and dealing with all possible forms of protest devoted to all imaginable objectives: the struggle for free love, anarchism, conservation of nature, the peace movement, the liberalization of drug laws, etc. A bare-breasted young woman demonstrates in almost painful isolation against the background of an architectural phallus for peace and love (Ill. p. 52), a laughing demonstrator holds out a fake bomb (Ill. p. 60), children holding banners like shields in front of themselves suddenly turn, also in near embarrassment, towards the photographer (Ill. p. 50), Allen Ginsberg advertises for "pot" (Ill. p. 58), two Black civil rights workers sit on a stairway after an event identified by two remaining slogans (Ill. p. 40). The last example is dominated by a contrast of black and white that serves to melt the tectonic structure of the photograph and its substantive message together, a stylistic characteristic we find in numerous photographs by Ben Fernandez. The crowd behind a barricade appears threatening, an

[1] Quoted and translated from Roland Barthes, *Die helle Kammer. Bemerkung zur Photographie* (Frankfurt am Main: 1985) p. 122.

[2] Quoted and translated from Max Kozloff, "Über den Kamera-Blick" (1979) in Wolfgang Kemp, *Theorie der Fotografie,* Vol. III, 1945–1980 (Munich: 1983) pp. 261–273, p. 269.

impression intensified by the direct gaze of a man with clenched fist rising out of its center (Ill. p. 48). Driven by concentrated emotion, the crowd has been herded into the smallest of spaces and threatens to explode the narrow confines of the picture; apparently, it will only be a matter of time before the barricades fall. In another instance, we are confronted with naked violence. A policeman threatens the photographer with his weapon (Ill. p. 53), an obscene pose that smacks of sexual coercion. It is no accident that Fernandez photographs from below, a perspective that lends the rows of helmets in front of the continuous wall of buildings a formidable power. Nonetheless, the faces of the protagonists reflect very different feelings. Our gaze moves from the bluntly threatening gesture to what Barthes calls the "point" (*punctum*) of a photograph, something that outlasts the photograph in our memory but never represents the whole, always condensing itself instead in a detail, as happens in this case in the facial expression of the soldier on the left. His body suggests restraint, his gaze mistrust, fear, curiosity, a whole range of vague suspicions. Here is an invitation to continue the story, to fantasize beyond the visible facts, to create an image of the person and invent a life. And this naturally touches upon an aspect that Susan Sontag addresses in her criticism of the fundamentally voyeuristic tendency of photography: the "examination" of a life without responsibility or intervention.[3] Ben Fernandez, the photographer, takes a position by choosing a view from below, thus making his standpoint clear. But a discrepancy arises which Sontag cannot accept: "While real people are out there killing themselves or other real people, the photographer stays behind his or her camera, creating a tiny element of another world: the image-world that bids to outlast us all."[4] The photographer responds to the aggressive behavior of his subject with his own resources, which appropriate reality by force, carving a slice of time from the life of the other, and thus certainly have something to do with power (or a balance of power). This is evident in other examples as well and is certainly a fundamental condition of photography per se.

What, then, makes a good photo-story? A single photo may be enough, but more often the elements are distributed "in time and space."[5] The story develops in primary and secondary settings. Fernandez enters the crowd, picks out representative participants and thus reveals the heterogeneous composition of the protest and Civil Rights movements. In accepting this diversity Fernandez earned criticism for being too eclectic, but it is an approach he believes in: "I didn't select the right or the left. I tried to portray all aspects: I photographed homosexuals demonstrating for equality in the draft, Buckley protesting Martin Luther King, King making speeches. I took an eclectic view of the protest movement … That's the beginning of all photography – making a choice,"[6] which means achieving a clear assessment of one's personal view of things.

Photos of crowds, full of rhythm and dynamism, flank the *Protest* series. Two canyons between high-rise buildings come from different directions, flowing together at their junction in the center of the city where no further separation of the factions is possible. But above the scene waves the U.S. flag, whose unqualified symbolic power has accompanied the history of photography from the time of Walker Evans to that of Robert Frank and Garry Winogrand and is now an indispensable part of its repertoire of motifs (Ill. p. 45).

Ben Fernandez bade farewell to classical, commercial photo-journalism when he recognized his subjects' right to their own privacy and, consequently, their right to grant or refuse approval for the photographs. *Paris Match,* one of the world's most prominent magazines, was of a different opinion. The bone of contention was a photo showing the children of the Black Baptist minister and civil rights leader Martin Luther King (1929–1968), who was slain by an assassin's bullet (Ill. p. 42). The photo focuses upon the group, standing close together and bent over the casket. The arrangement of the children's heads describes an oval that encloses the private, emotional space. The photographer stands at the fringe of the scene, but not outside the circle. He had met Martin Luther King during the previous year and made several portraits of him. The situations in these pictures are usually open: One sees Martin Luther King crouched behind a grandstand,

23

3 See Susan Sontag, *On Photography* (New York: 1978) pp. 40.
4 Ibid. p. 11.
5 Quoted from Henri Cartier-Bresson, "Der entscheidende Augenblick" in: Wilfried Wiegand (ed.), *Die Wahrheit der Photographie. Klassische Bekenntnisse zu einer neuen Kunst* (Frankfurt am Main: 1981) pp. 267–282, p. 270.
6 Interview with Kathryn Livingston in *American Photographer,* 5/85, p. 78.

surrounded by insistent companions (Ill. p. 37). The most striking feature of the image is the strangely absent, introverted gaze of the protagonist, which, although it seems almost to disappear in the crowd, attracts attention and poses questions: What is he thinking? What is he looking at? Does he suspect the worst? What will he do? What is he doing there at all? This same face is evident in another picture, impenetrable, opaque, calm, bearing witness to an inner peace that is astounding (Ill. p. 36).

One may reasonably assume that Ben Fernandez's personal origins and life history contributed to the intensification of his sensitivity to humanitarian issues.

Beyond that, Alexey Brodovitch and the New York scene during the 1960s had a major influence upon Ben Fernandez's choice of motifs and his aesthetic approach to photography. Here lie the roots of this photographer's style and identity, and it is worthwhile to examine them in order to arrive at an understanding of his own unique language. First, there is his beloved/hated mentor, Alexey Brodovitch (1898–1971), the famous/infamous guru of New York's world of design and photography during the 1940s and 1950s. His "school" produced a number of noteworthy artists, including Lilian Bassmann, Leslie Gill, Richard Avedon, Irving Penn, Ben Rose, Diane Arbus, Lisette Model and many others. Ben Fernandez, one of his last students, remembers his teacher's extreme demands: "Brodovitch demanded more from people than they were willing to give, but this gave them an understanding of what they were capable of" (Benjamin J. Coopersmith). The Russian immigrant, once a graphic artist and designer for Serge Diaghilev of Paris, among others, revolutionized the image of graphic design in the U.S. after 1934 from his position as art director for *Harper's Bazaar*. Naturally, Brodovitch promoted primarily the fashion genre, through such figures as Martin Munkacsi, Man Ray and Richard Avedon. But in his efforts to give *Harper's Bazaar* a new, artistic image, he incorporated documen-

tary photo sequences by Bill Brandt, Brassaï (actually Gyula Halász), Henri Cartier-Bresson and Lisette Model. To young New York talents on the move he represented the epitome of style and success. His Design Laboratory, a workshop he directed at the New School for Social Research beginning in 1941, had become a legend in its own time.[7] Instruction ordinarily took place in Richard Avedon's studio. Part mentor, part guru and father figure, Brodovitch ruled his students with an iron hand, stimulating them to find their own way somewhere between rebellion and submission. He saw himself less as a teacher, in the classical sense, than as a "can opener, someone whose role, as an art director and as a teacher, was to encourage creativity, not to codify it."[8] The students were eager to please him, the man who needed a never-ending supply of visual stimulations as a kind of life-giving potion. Though his difficult personality caused them problems, he remained a fascinating figure. Ben Fernandez, who surely appreciated his revolutionary perceptiveness and his unerring artistic sense, once remarked: "To some people he was like a god, but to me, he was a bastard."[9] Brodovitch convinced Fernandez of the possibilities inherent in the creative process and strengthened his belief in himself at the same time. That was the objective he pursued in his workshops: "My classes are not for the purpose of learning the technical aspects of photography nor are they concerned with a particular style of photography. They are really laboratories in which photographers are free to experiment and to find a direction of their work."[10] In his own teaching, Fernandez revealed his appreciation for his mentor's approach as he continued to communicate Brodovitch's message. He, too, is dedicated to fostering individual talents: "I believe that there are no two people alike in this world and that students must be made to recognize their own uniqueness. We've got to stop them from copying and mimicking the greats and allow themselves to be great, to develop new ways of seeing."[11] Thus like Brodovitch, Fernandez seeks above all to show students how to find their own personal expression and to translate into a photographic language.

When Ben Fernandez chose his new profession in the early 1960s American photography, under the influence of social change, found itself at a turning point. Until then, the history of American photography had followed a relatively uniformly accepted linear course,

7 See *Alexey Brodovitch,* exhibition catalogue (Paris: 1982). Brodovitch returned to France in 1962. Every year since 1967, the American Society of Photographers has sponsored the "Alexey Brodovitch Design Laboratory."
8 Quoted from Andy Grundberg, *Brodovitch* (New York: 1989) p. 22.
9 *Ibid.* p. 20.
10 Quoted from *Alexey Brodovitch,* exhibition catalogue, op. cit. p. 123.
11 Quoted from interview with Kathryn Livingston, op. cit. p. 78.

only to become the highly pluralistic discipline it is today. The "heroic" era of American photography comprises generally well-known phases, beginning with Alfred Stieglitz and his New York circle, followed by the campaigns of the FSA (Farm Security Administration), the West Coast group "f64," the Chicago School of Design and eventually by artists recently associated by Jane Livingstone under the rather daring name of "New York School," including such figures as Diane Arbus, Richard Avedon, Alexey Brodovitch, Ted Croner, Bruce Davidson, Robert Frank, William Klein, Lisette Model and others.[12] They all undoubtedly belong to the generation referred to as "those lost outriders of a spent romanticism."[13] And they all belong within the tradition of "straight documentarism" and can be associated to a certain extent with the humanism proclaimed by Ray Stryker in the name of honesty and individual dignity.[14]

The view of society changed, however, as is already evident in Robert Frank's volume of photos entitled *The Americans,* published in 1959. A comparison with Walker Evans's epic, *Let us Now Praise Famous Men* (reprinted in 1960) makes the difference quite clear. For Walker Evans the only flaw was poverty, shared by people otherwise honest, upstanding American citizens. In Frank's book, on the other hand, we find some people living apart from society who have no interest in integration. The work of a "joyless man who hates the country of his adoption" was seen as an "attack on the United States."[15] While Steichen emphasizes the unity of mankind in his 1955 exhibition "The Family of Man," that unity is split apart and irreversibly shattered in the view of subsequent decades.[16] Photojournalism enjoyed incredible growth in the 1940s and 1950s. Photographers acting like kings pursued the visualization of the American way of life. The country was convinced of its mission in the world, and a homogeneous image of American society was conceived. In these reportages, "virtually everyone is white, middle-class and a member of a small nuclear family."[17] Near the end of the 1950s, however, signs of a crisis appeared on the horizon. America's weakening influence abroad, its growing racial problems and continued economic stagnation clearly pointed to the arrival of grave problems that could well lead to the loss of the country's traditional identity. As we know, the decades that followed shook the nation's foundations to a degree never before ex-

perienced. In the wake of racial unrest, the peace movement, the beat generation, Vietnam and Watergate, all attempts at restoring the old image of a national identity were doomed to failure. Suddenly the differences were there for all to see, the wounds of a society exposed.

In view of the immediacy of the horrors of Vietnam, photography soon reached the limits of its capacity to report global events.[18] Liberated from service to the American ideal, photography turned increasingly to issues of social diversity and fragmentation, to people and their abnormal obsessions. Whereas the immigrant family was the archetype of the 1930s, this role was assumed in the 1960s by the deformed individual as typified by napalm victims on the war front and by freaks at home. The most extreme of the bohemians were the "rock freaks, the speed freaks, the bike freaks."[19] Against this background, the photo-series produced by Ben Fernandez provide a portrait of one of the most incisive eras in American history. Their plurality is in keeping with the structure of the times. Historical facts serve as a safety net for the documents of memory, which rise up to dam the tide of impermanence and mortality,[20] in

[12] See Jane Livingstone, *The New York School. Photographs 1936–1963,* (New York: 1992) p. 259.

[13] Ibid. Quoted from Sven Birkerts, *The electric Life. Essays of Modern Poetry* (New York: 1989).

[14] Ray Stryker (director of photo projects within the framework of FSA activities) quoted from *1920 Amerika Fotografie 1940. Zwischen Hollywood und Harlem,* exhibition catalogue (Hanover: 1980) p.171.

[15] Quoted from John Szarkowski, *Mirrors and Windows. American Photography since 1960* (New York: The Museum of Modern Art, 1978) p.19.

[16] As a signal for this development reference is made to the photographs of Diane Arbus exhibited at the Museum of Modern Art in 1972. She shows a world in which everyone is a stranger, "hopelessly isolated, immobilized in mechanical, crippled identities and relationships." Quoted from Susan Sontag, op. cit. pp. 36.

[17] James Guimond, *American photography and American dream* (Chapel Hill and London: 1991) p.152.

[18] John Szarkowski points out another interesting development of this period, one which took on importance for Ben Fernandez as well: It was during the 1960s that photography was increasingly being discovered and introduced in schools and universities as a discipline in its own right. By 1970, educational institutions that did not offer at least a course in photographic technique were considered underprivileged. See *Mirrors and Windows,* op. cit. p.15.

[19] Jonathan Green, *American Photography. A Critical History 1945 to the Present* (New York: 1984) p.120.

[20] See Klaus Honnef, "Fotografie zwischen Authentizität und Fiktion," in *Documenta 6,* exhibition catalogue, vol. 2 (Kassel: 1977) pp.11–27, p.23.

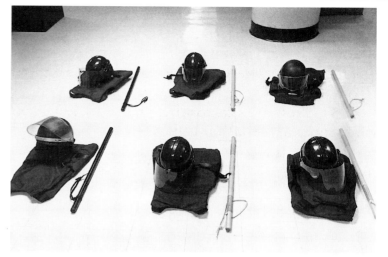

Detention Center, New York, 1986

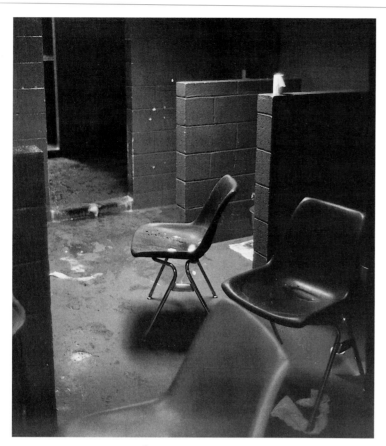

26

Detention Center, New York, 1986

"continuous opposition to the actuality of life, to incessantly changing reality."[21]

Fernandez allowed himself to be guided by the existing diversity and followed its rhythm. The *Protest* series and the photos of Martin Luther King were born of the historical context. Yet another sequence belongs in this category as well. Beginning in 1985, Ben Fernandez devoted a revealing series of photos to the motorcycle freaks who meet annually in Daytona Beach, Florida. In this work he succeeds in expressing his own critical thoughts while closely examining the myth of the American biker. Here as well he sought to break through the anonymity of the crowd with shots of individuals, achieving a documentation of standard behaviors and stereotyped gestures that reflect the social codes of an insular community (Ill. p. 74 and 77). The central focus of the series is the absence of human relationships in a group of individuals who interact exclu-

sively with their machines. Fernandez is motivated in this case as well by the specific manifestation of the other, as he investigates the conditions of their lives and then subjects them to an aesthetic transformation in his photographs. In these pictures he concentrates upon a narrowly defined detail as a symbol of the limited spectrum of their world. There is barely room left for female companions, as status symbols, whose primary function is to expose their breasts. With remarkable casualness they perform their roles in a kind of monstrous show. The sexual power structure is clearly defined. The appeal lies not in the revelation of their female qualities, but in a concrete demonstration of their availability (Ill. p. 73, 75 and 80). In keeping with the absurdity of the situation, Fernandez often approaches from an oblique perspective. He actually achieves a proximity that makes viewing the pictures somewhat unpleasant, as if he were following the unsteady steps of one of his subjects. If the biker was once close to our hearts as a legitimate outlaw ally in the battle against parental authority, we would now find it difficult to recreate such nostalgia. With great effort, the fantasy of a questionable freedom is reconstructed in a delirium of drugs and alcohol and adorned with bare breasts.

Ben Fernandez's methods give the pretense of innocent observation on the part of the photographer. Curious, he approaches his subject, whether it be the bare-breasted snake-charmer or the tough guys on their big machines. Through detail and perspective alone he reveals "more than meets the eye,"[22] an insight into things that must come from a deeply humanitarian conviction.

[21] Quoted from Bernd Busch, *Belichtete Welt. Eine Wahrnehmungsgeschichte der Fotografie* (Munich, Vienna: 1989) p. 365.
[22] As Todd Papageorge comments on the photos of Garry Winogrand, with whom Ben Fernandez might be compared in several ways. See Green, op. cit. p. 111.

A similar, seemingly random view comes to light in the *Mental Poverty* series. Here, the photographer has selected entirely everyday motifs encountered everywhere, representing elements of typical daily reality. All the more frightening, then, when they are viewed apart from their customary context. The man barbecuing suddenly appears isolated and out of place in his marginal existence (Ill. p. 68). Nowhere is the *memento-mori* aspect of photography more obvious than in this otherwise so unspectacular shot. The slightly backward-bending figure cut off by the edge of the picture poses the quintessential question of the meaning of life. Emptiness yawns in the center, concealed by garden furniture. This immediately palpable suspension of time is contained above all in the magic of things that stare out at us, as in the row of wig-stand heads (Ill. p. 69). A mirror in the center of the photo permits us a look at a room filled to the brim with objects that now encroach upon the limited space of the stage. The photographer appears to examine and record the significance of the objects in relation to the people who use them and furnish their surroundings with them. Ultimately, the people disappear, leaving behind things which tell stories of violence and loneliness: the plastic chairs in front of the wall buttresses framing a pissoir (Ill. p. 26), for instance, or police battle-gear arranged in orderly rows, carefully prepared for the next operation, without the least sacrifice of brutality (Ill. p. 26).

Photography penetrates spheres of life that ordinarily occupy the blind spots of human perception. Treating objects and human beings, technically speaking, in the same way gives them equality in the photograph. As the object's value is enhanced, the importance of the human decreases.

Fernandez is not one of those photographers who fragment segments of reality and compose them as montages, as is the case, for example, in the photographs of Lee Friedlander. Instead, he selects views, according to graphic or tectonic considerations, that are reminiscent of the compositions of Walker Evans and Edward Weston. The arrangement of police helmets, for instance, has a structure similar to that of a photo from the series entitled *Machismo – Puerto Rico* showing a man behind a kind of balcony screen (Ill. p. 86). Some of the Puerto Rican images are given a clear structure through axial symmetry and central perspective, which correlates to the system found in the hierarchically oriented society based upon power and powerlessness. Thus the view of a stairway and an Army recruiting poster at its foot (Ill. p. 91) has affinities with the portrait of three elderly men sitting in a row against a wall (Ill. p. 84). The point is not so much the "decisive moment" (Cartier-Bresson), as it is the perception and exploration of existential relationships that are expressed most poignantly in the congruence of subject and the architecture of view.

For this reason, pictorial language also changes according to theme. In his travel photographs Fernandez concentrates upon fleeting impressions, upon the sense of traveling itself and upon encounters among travelers, as can be seen in the photos from China. Each of them represents a brief stop in the flow of a movement that has gripped the artist and at the same time makes a fundamental contribution to the character of his photographic art.

In the *Japan* series, on the other hand, he becomes a fearless snapshooter, a radical street photographer who whirls about his own axis, stopping spontaneously to capture the unfamiliar society caught in the field of conflict between tradition and western influence. Going beyond a mere inventory of reality, Fernandez consistently seeks appropriate images for the essentials and the principles hidden within the visible. In leaving the world as it is, he unveils its secrets.

Ben Fernandez and the Photojournalism:
I AM A MAN

Christiane Gehner

If I had to choose two photographs from the extensive Ben Fernandez collection, it would be these: "Poor People's Campaign, Memphis, 1968" (Ill. p. 40) and "Anti-Vietnam-War Demonstration, Washington, D.C., 1965" (Ill. p. 29).

In very significant ways, each of these pictures provides both comprehensive and conclusive insights into the photographic work of Ben Fernandez, and together they say even more about the artist's personal and professional identity, a matter about which I shall have more to say in the course of this essay.

The first photograph shows a placard. Although I am forced to read it upside down, it is the first thing I notice within the hierarchy of eye-catching pictorial elements. Surely, the multiplicity of meanings contained in the concise statement, "I am a man," must have appealed intuitively to the (then) 32-year-old photo-journalist – or photo-anthropologist, as he later chose to call himself after some reconsideration. If we examine all of his portfolios in chronological sequence today, we find that there is no more fitting expression for his quest for humanity and his personal search for masculine self-awareness than this: *I AM A MAN*.

With signet-like clarity the second photograph shows the shadow of a hand pressing the button of a 35-mm camera – this in the midst of a scene characterized by tumultuous, barely recognizable activity. The viewer of this news photo is reminded of the fact that he occupies the same position as the photographer. The photographer permits him to take part in the action that has taken place far away and quite apart from his own reality. The position of the photographer Ben Fernandez with respect to his media function as a photo reporter and a witness to history can hardly be made clearer than this. It would be impossible to write about the work of a photojournalist without reference to the current state of photojournalism, of the printed and broadcast image, and without examining mechanisms of media utilization and techniques of formal presentation. The photographer's retrospective assessment of his own life's work and his appraisal of its meaning pose for both him and us the question of how the effect of his pictures relates to the function originally assigned to them: to inform and to move, or expressed somewhat more boldly: not only to inform, but to move at the same time. And thus a politically motivated Ben Fernandez arrives at the question: Can my pictures become a political weapon?

For the politically committed photojournalists of the 1960s, the decade of the Civil Rights movement in the U.S., and for those in Germany in the period around 1968, the years of student revolution, this question was the heart and substance of their everyday work. Because the tendency at the time was to act first and entertain doubts about one's own actions later, if at all, the question was quickly answered. Yes! Pictures of street-fighting, of the misery of those deprived of their rights, of the arrogance of government authorities were a weapon if printed and circulated in sufficient numbers. Today we know one thing for certain, and that is that we shall never know precisely how authentic pictures and those intended as authentic actually affect the viewer, no matter how much we would like to believe that they actually achieve such affects.

But let us return to Benedict Joseph Fernandez III and the Sixties in the United States. The native New Yorker, 25 years old at the time, had a "Black" name. He was raised in Spanish Harlem, the son of a Spanish-speaking immigrant father from Puerto Rico and an Italian-American mother. Having taken up photography early in life, he worked originally as an engineer in order to feed his family. Eventually, unemployment forced him to turn his hobby into a profession.

He began with small features and wedding pictures. During this period he became increasingly conscious of his own social status as a Latino in white America, and that against the background of the revolutionary events that were taking place in the streets of nearly every major American city – the non-violent Civil Rights movement under the leadership of Dr. Martin Luther King. During this critical and uncertain period in American history Fernandez became an active participant in the movement. More than dissatisfied with television reporting – he had already learned a great deal about the potential use of image manipulation for propaganda purposes – he became a photojournalist and agitator by necessity, in order to support Dr. King's ideas and convictions.

In the years that followed, Ben Fernandez photographed in the streets of New York, eventually becoming one of the most important "street photographers" of his time, thanks to his ability to recognize significant socio-political events. By the time the war in Vietnam ended he had put together a virtually continuous photographic diary of the American anti-war movement, as expressed

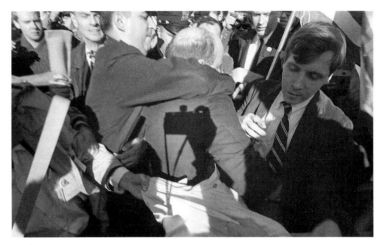

Anti-Vietnam-War Demonstration, Washington, D.C., 1965

in the increasingly massive protest marches that took place on the streets of Manhattan and Washington. June 2nd, 1966 represents a special milestone in his biography, a turning point in his life. On this day the *New York Times* published its first Ben Fernandez photo: "Students burning their draft cards in protest of American involvement in Vietnam" (Ill. p. 49). From that time on his photographs appeared in the press every week. Agencies and editors became interested in him. He became a permanent freelance contributor to the *New York Times,* and now other assignments followed – local news items and features. Political photojournalism remained the most important part of his work, however. Fernandez clearly recognized the historic dimensions of the times and his role as the chronicler of a movement that was developing from its origin in the Civil Rights movement to become the Human Rights movement. Without a doubt, Martin Luther King was the most important figure in the life of the young Ben Fernandez. He took every opportunity to be near the great leader, and thus it is not surprising at all that the photographs collected in the book *Countdown to Eternity* are the most impressive, warm-hearted and tender pictures to be found in his entire photographic work.

Several teachers and mentors influenced his work and may have helped shape his strong visual talents: the graphic artist and art director Alexey Brodovitch and the photographers Lisette Model and Minor White. Brodovitch also encouraged him to pass his experience on to younger photographers. He secured the young man a position as lab technician for Allen Porter, at the time an instructor at the New School/Parsons School of Design and later editor of the legendary Swiss maga-

29

zine *camera*. Fernandez established the Photo-Film Workshop at the New School and eventually developed a program of graduate studies in photojournalism. The highly committed, perhaps somewhat overeager street photographer had matured to become a teacher and communicator. Soon he expanded his teaching activities into the international sphere, setting up an exchange program with Russian photographers and finding partners in France and Germany as well. For many years he served here in Dortmund as the initiator and co-organiser of Focus, an annual symposium for students of photography at the *Fachhochschule für Gestaltung.*

But let's go back to his own work again. In 1969, near the end of the political movement, Fernandez was awarded the prestigeous Guggenheim Fellowship, not for a specific political photo project, but on the basis of his expressed intention to photograph, whatever his topic might be. The movement he had so vehemently embraced came to an end under the Nixon administration in the early 1970s. Fernandez began traveling more often and to more distant locations. He explored his own roots in Puerto Rico and discovered Spain, Japan, China and Russia. He must have come to the realization during these travels, if not even earlier, that one could not always work on the basis of political conviction alone, that it was really necessary to define one's own position as an observer and narrator. Depicting people in their own living situations through photography – working as a photo-anthropologist, in other words – struck him as the most appropriate approach. And the theme *I AM A MAN* continued to hold his attention. His series on the motorcycle clubs and their gatherings in Daytona Beach addresses the question of masculinity, which is also at work in the Puerto Rico photos. As a teacher and mentor he returns repeatedly to the principle, so essential for the young photographer, of interplay between the reporting of external and public events and the processing of personal experience through photography. He insists, that this is an essential prerequisite for anyone who wishes to become a truly good photojournalist.

Now, of course, even Ben Fernandez recognizes that the possibilities for a photojournalism based upon his own definition are severely limited.

In our advanced Age of Communications we know much more about what journalistic photographs can and cannot do. In the U.S. the role of the printed photo in the era of television was stripped of its documentary, reporting function as far back as the early 1970s. Everything else photography remained capable of doing was shown in the print media, which were themselves becoming increasingly insignificant, however: creatively designed color-photo features were meant to stimulate, thrill and enthuse the reader; to awaken yearnings, to comfort and to motivate. The great models were still *Life, Look* and *National Geographic.* In demand were well-researched long-term projects by specialists with both technical and artistic skills and, on the other hand, creative producers of symbolic images for the eye-catchers. Work was also available for sensitive portrait photographers with logistical talents, adept at capturing political and social celebrities in the right light. It was the heyday of the specialist. The rapidly accelerating reproduction effect led to an equally rapid proliferation of new television programs. In view of photography's increasing technical versatility and its susceptibility to manipulation, serious, enlightened photographers were soon moved to distrust, or perhaps only to skepticism, with respect to the possible uses of their pictures in the print media. They became increasingly aware of the many ways in which images could be made to state claims and falsify facts in a variety of different contexts. The emulsions and properties of color films went along with general trends in color preference, making it possible for every photographer, amateur and professional alike, to immerse even the most horrible of scenes in a tender and beautiful light. It had become clear to everyone just how close the alliance between photography and lies could be. Motivated by this skepticism, many photographers developed other forms of expression of their own, now generally referred to as "author photography." These photo essays, which tend to criticize or undermine popular clichés, have rarely been permitted much space in the American print media. The public is more likely to find the work of Mary Ellen Mark, Joel Sternfeld and Eugene Richards in exhibitions and catalogues than in newspapers and magazines. *Time* and *Newsweek,* on the other hand, still make use of news photography, occasionally printing even major photo features covering five to six pages. Beyond that, with the exception of a few daily newspapers, the forum for the genre of "concerned photojournalism," now unfortunately regarded as obsolete, has virtually disappeared.

Noteworthy exceptions include the *Missouri Standard,* known for its commitment to serious, current photojournalism. The Missouri Photo Workshop remains one of the few institutions in the world today still capable of setting standards in classical pictorial reporting.

The *Washington Post* and the *Detroit Free Press* also remain committed to printing and promoting the work of photojournalists. David Turnley and Carol Guzy, both recipients of the prestigious World Press Photo Award and the Pulitzer Prize, began photographing for these papers at a young age and have worked continuously for them for many years, which permits us to conclude that their working circumstances are less alienating than those of their colleagues at news agencies and other newspapers and magazines. Of course the *New York Times* and other major newspapers also employ good photojournalists, although there is evidence to show that the reach and impact of their work are not viewed as particularly significant. Today, the only place to find the classical picture story, whose power and effectiveness can only be achieved if it can be "laid out" over a sufficient number of double pages, is in the *National Geographic* magazine. Even *Life* no longer goes beyond three double pages as a rule. All of this, of course, has had its effect upon news-oriented photojournalists. Most of them moved on to doing life-style features for the growing number of special interest magazines: *Vanity Fair, Condé Nast Traveler, Sports Illustrated, Economist* – to name just a few. Delayed somewhat, this development has since also reached our own German media, also appearing hand-in-hand with the proliferation of private television broadcasters. In our country as well – and perhaps in particular – many serious photographers have brought their skepticism into thematic scope of their photo essays – and with quite noteworthy results, I think.

At some fifty institutions of higher education offering photojournalism as a course of study, alone or alongside other disciplines, we find a new generation oriented largely towards American influences (Joel Meyrowitz, Richard Misrach, Alex Webb, Gilles Peress) but also well aware of their own history and the history of photojournalistic styles in Germany. Thus it cannot be said that current trends and attitudes in our country represent nothing more than a passive assumption of American or other international positions.

During the early 1990s young male and female photographers stormed the editorial offices, presenting – in place of routinely underexposed color orgies on 35-mm slides – sophisticated portfolios and posterlike color enlargements that looked at first glance more like bad amateur photos. Over the years, tastes have obviously become more refined, and art directors and photo editors have begun to show some appreciation for these initially protest-based photo-essays and their critical approaches to classical photographic clichés. At the heart of this development is the quest for greater democracy for individual pictorial symbols and colors. The formal structures of classical photojournalism construct a compositional dramatization in accordance a hierarchy of individual visual/optical intentions. We are accustomed to viewing photographs in keeping with a certain perceptual scheme, and we prefer those that catch the eye directly and immediately to others that require a longer and more concentrated perusal. In my opinion, the photographers of the new generation are justifiably distrustful of this "eye-catcher" mentality. Without sacrificing their socio-political standpoints, they express the desire for more democracy in visual communication.

The best photo essays of this type found their way into German newspapers and magazines. Among the most adventuresome and consistent supporters of this development have been the periodicals *ZEIT* and *Suddeutsche Magazin* and the *Frankfurter Allgemeine Zeitung.* And if today more and more editors-in-chief than ever before are talking about a "new pictorial language," this suggests (though it does not necessarily prove) that there is still room for the often discussed, often neglected picture story, albeit, and fortunately so, within a more flexible and up-to-date concept of photojournalism.

Countdown to Eternity
Martin Luther King

Martin Luther King, UN, New York, April 1967

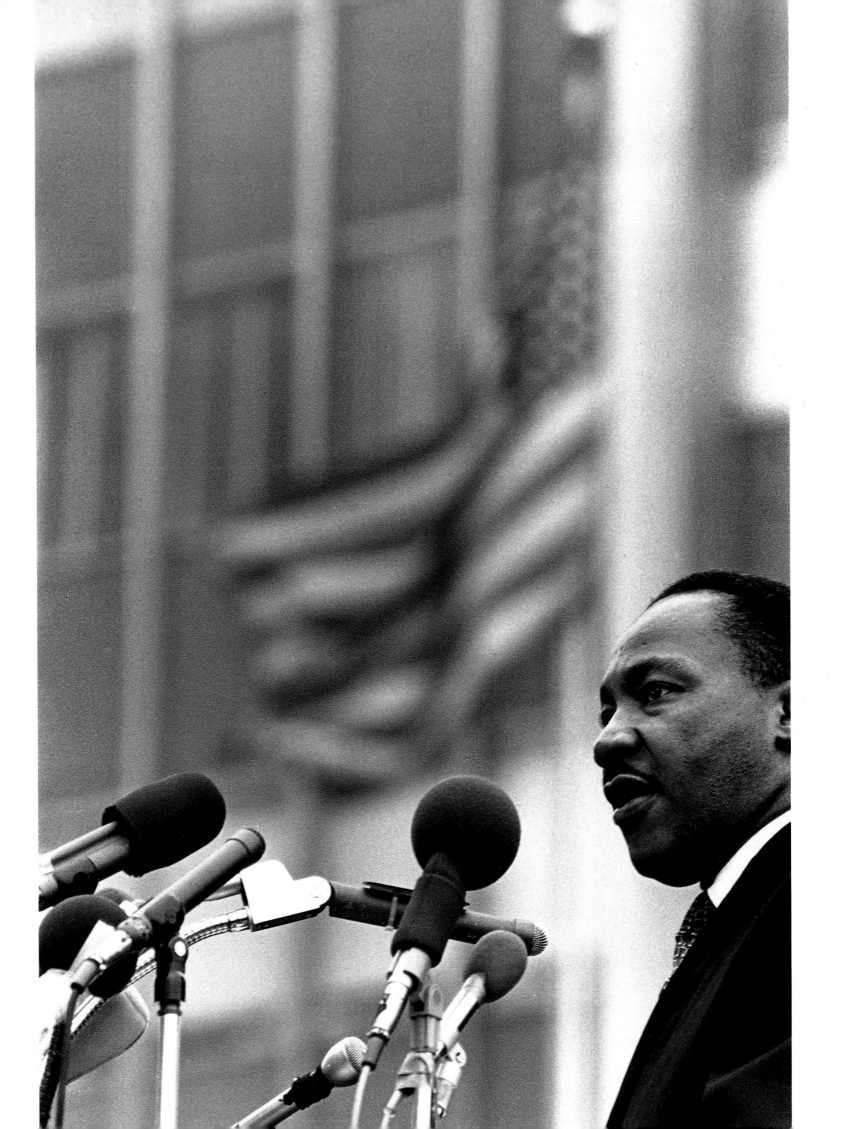

34

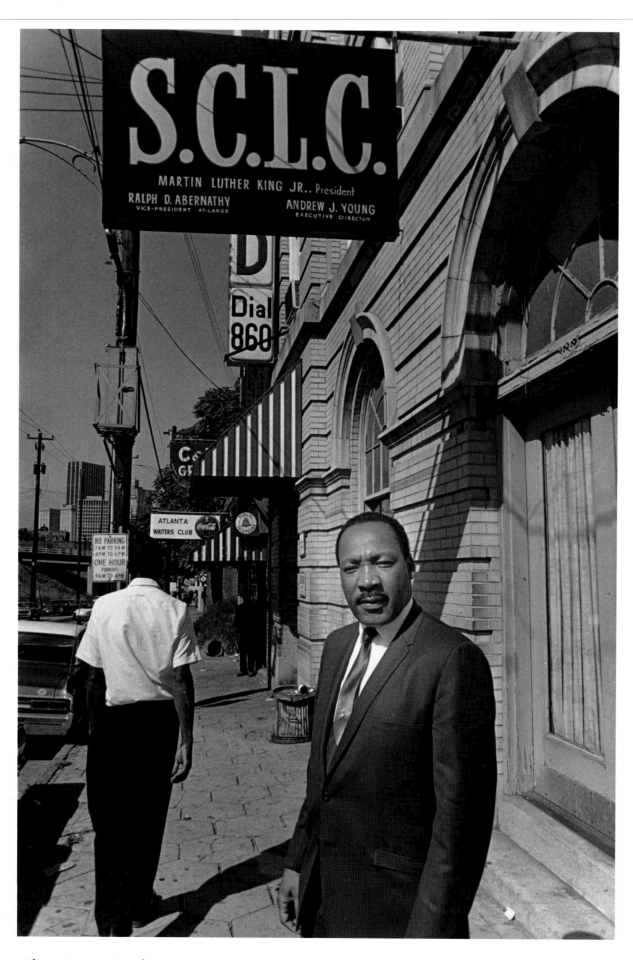

Atlanta, Georgia, November 1967

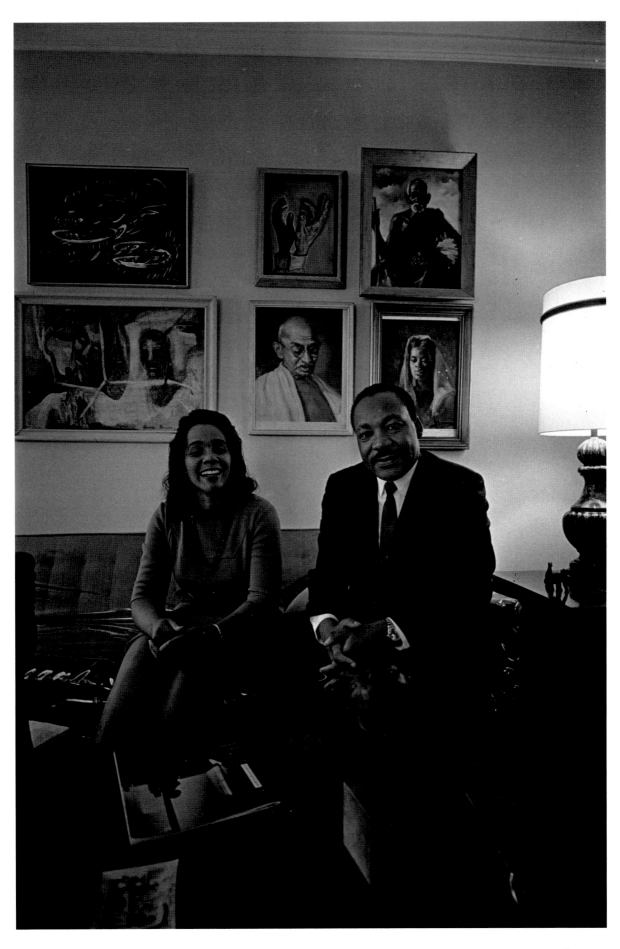

Atlanta, Georgia, November 1967

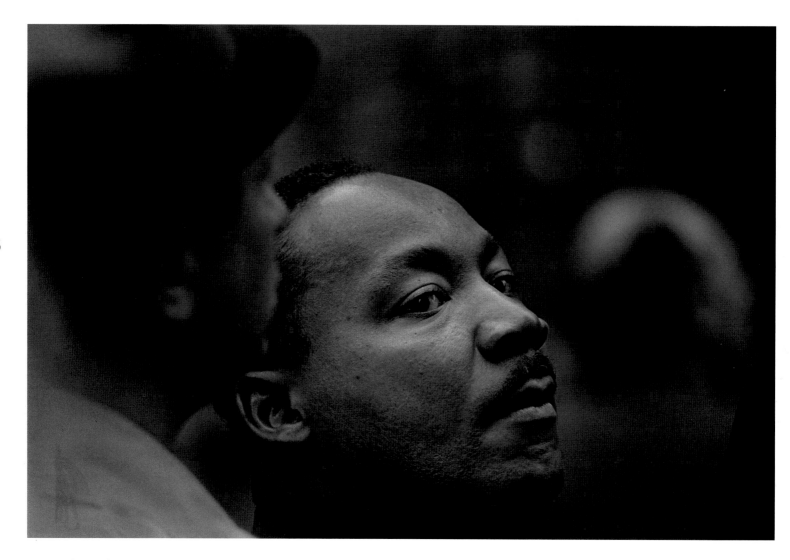

New York, April 1967

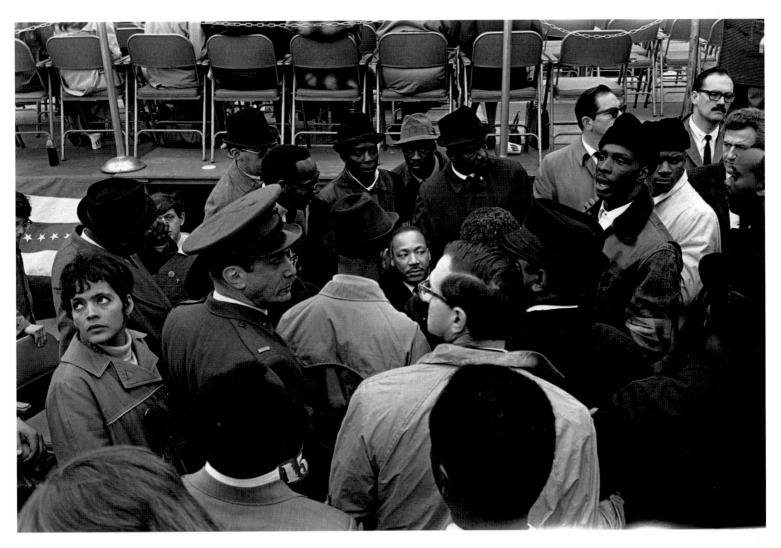

New York, April 1967

38

Washington, D.C., 1965

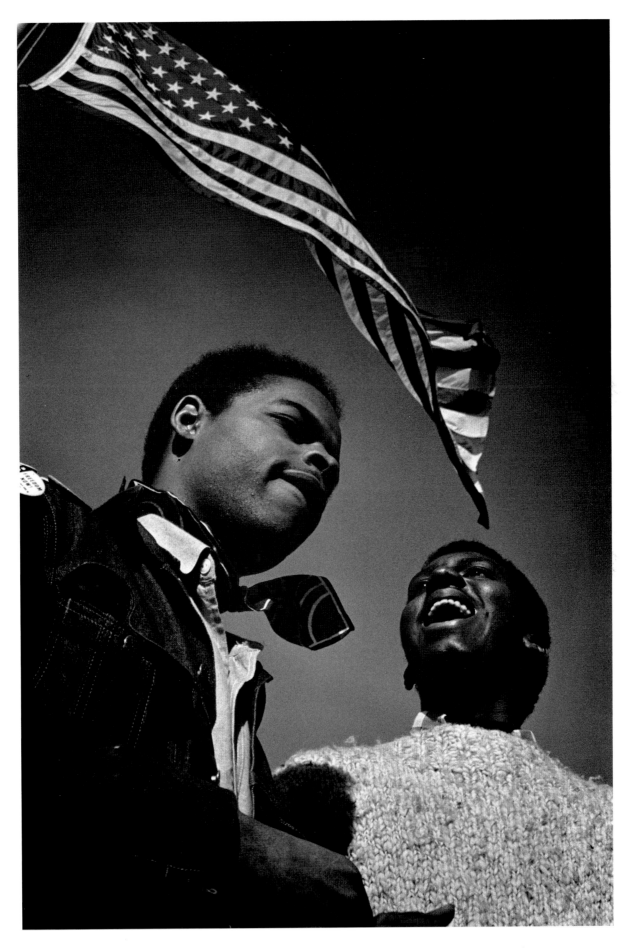

Washington, D.C., 1965

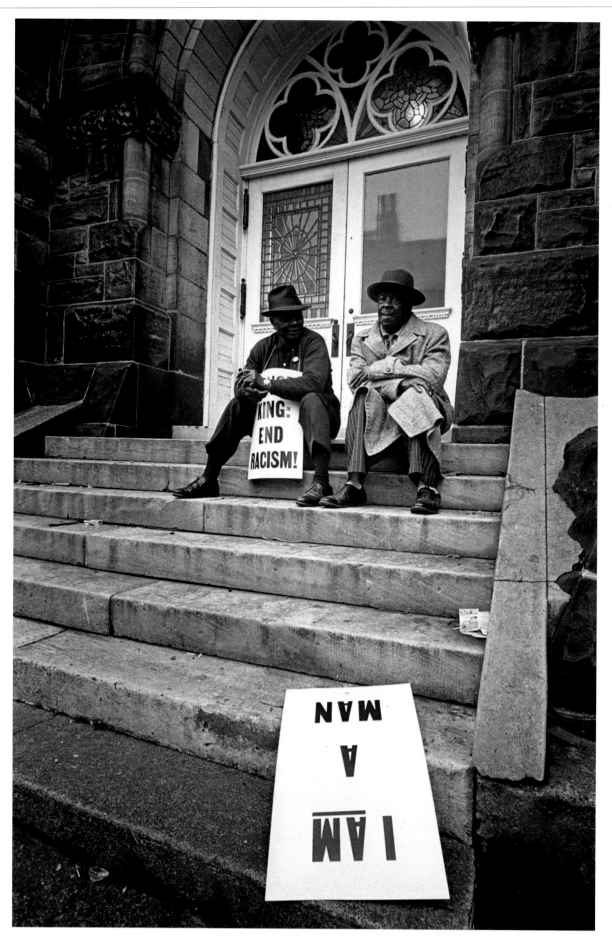

Poor People's Campaign, Memphis, 1968

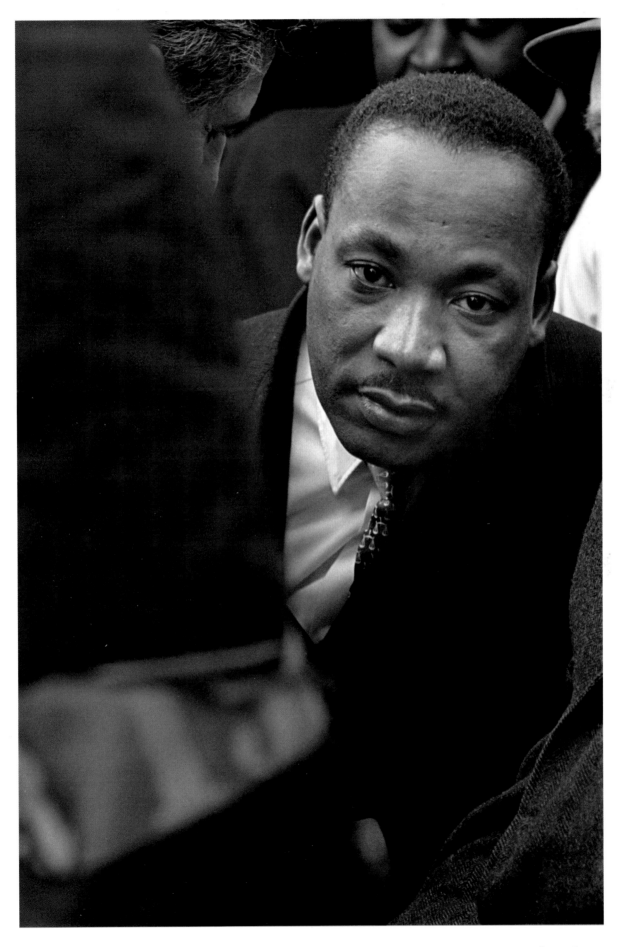

New York, April 1967

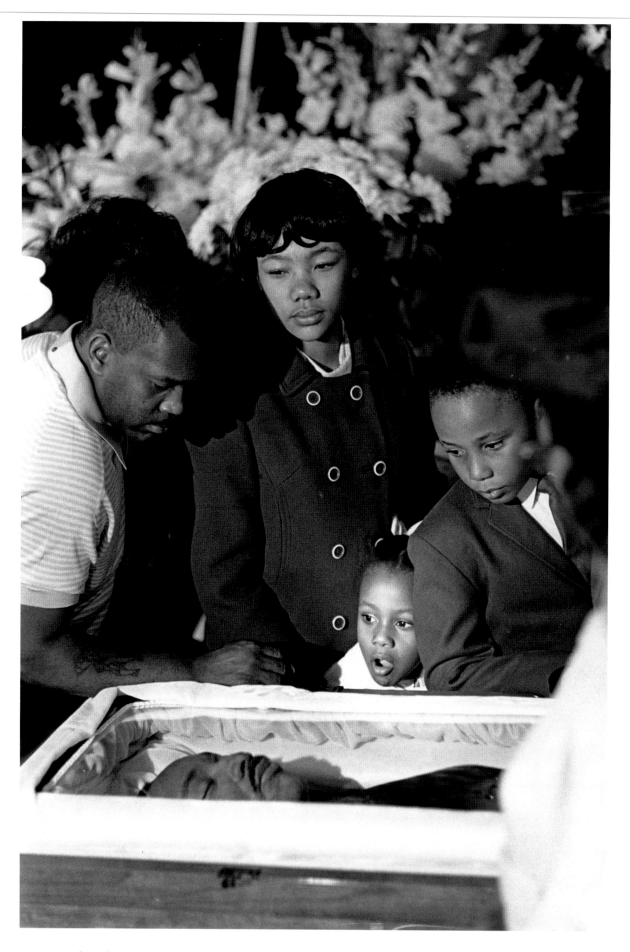

King's Family, Atlanta, Georgia, April 8, 1968

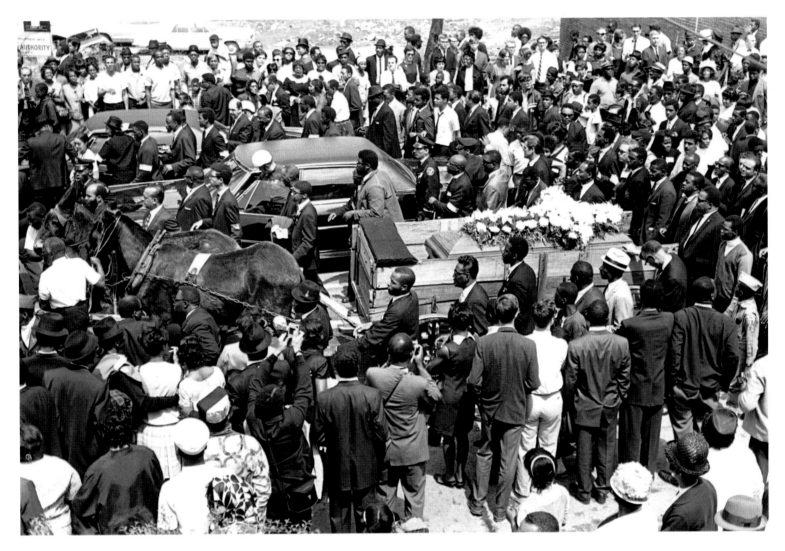

43

Funeral, Atlanta, Georgia, April 10, 1968

In Opposition

Pro-Vietnam-War Demonstration, New York, 1970

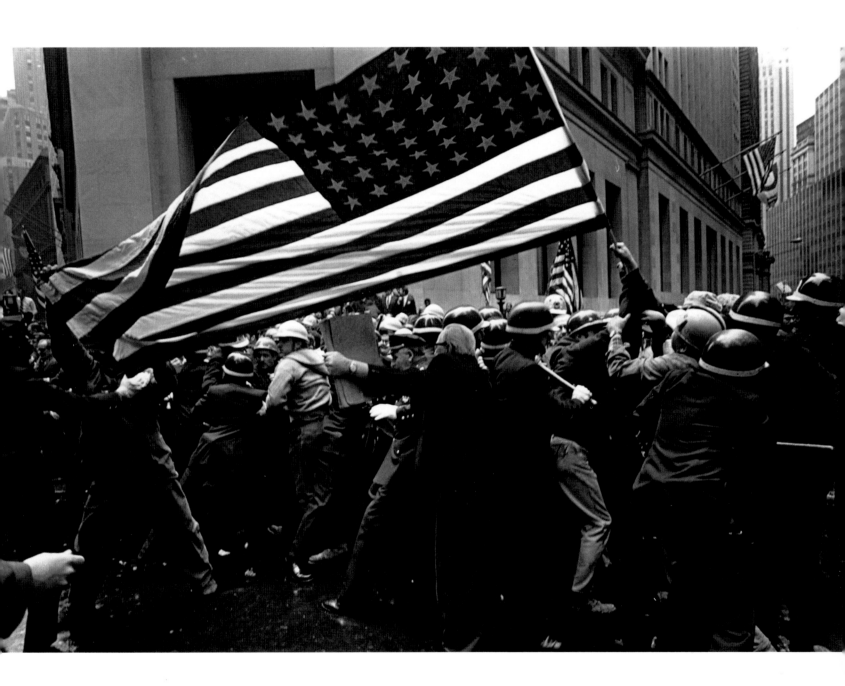

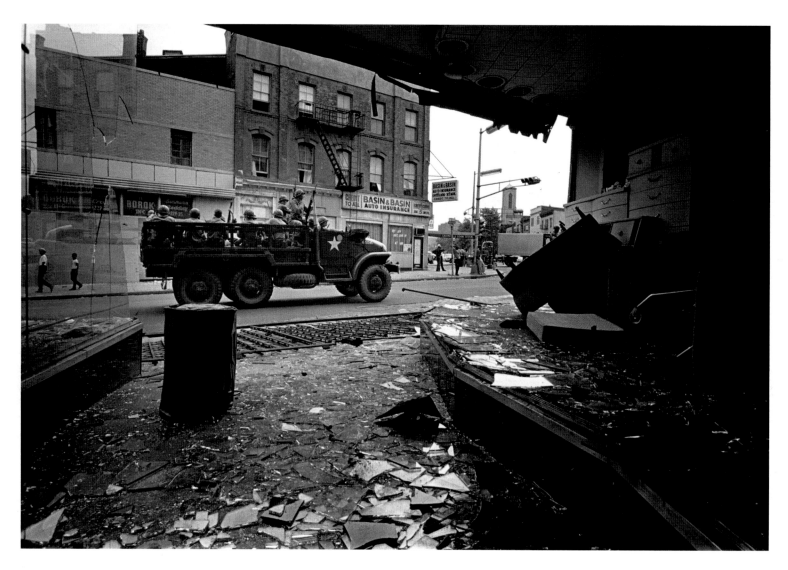

Black Riots, Newark, New Jersey, 1967

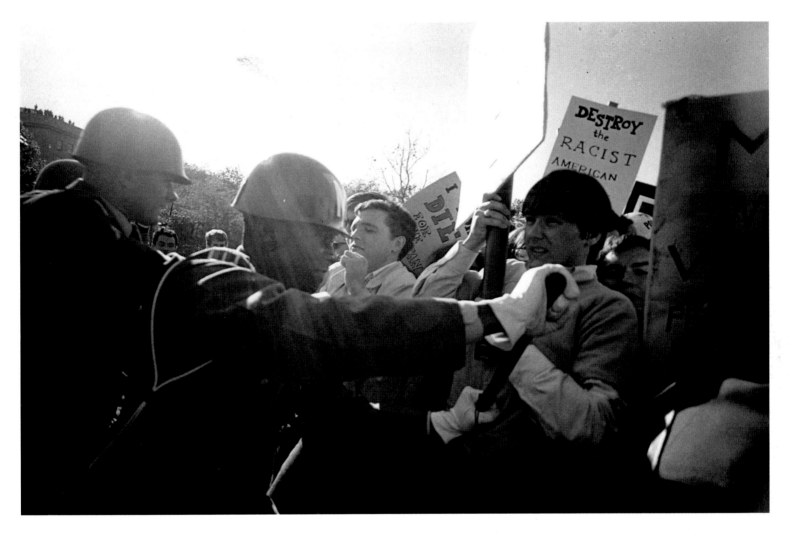

Anti-Racism Demonstration, Washington, D.C., June 1968

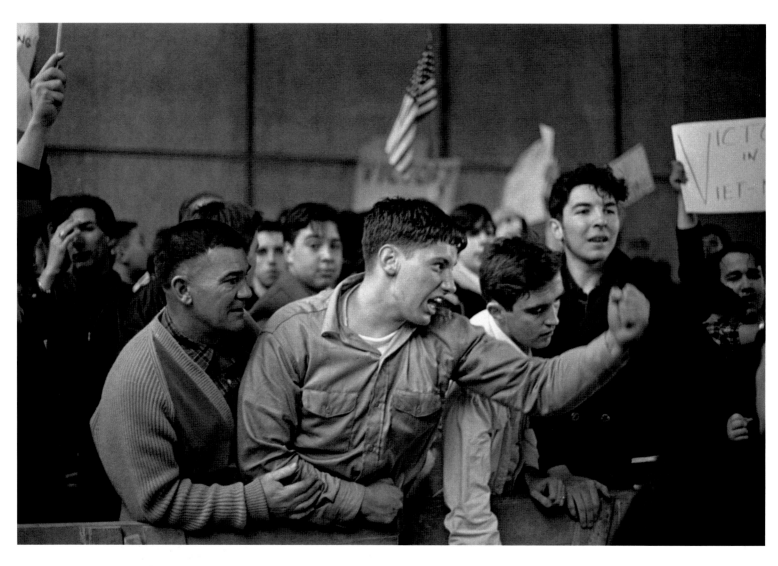

Anti-Vietnam-War Demonstration, New York, April 1967

Burning of Draftcards, New York, 1963

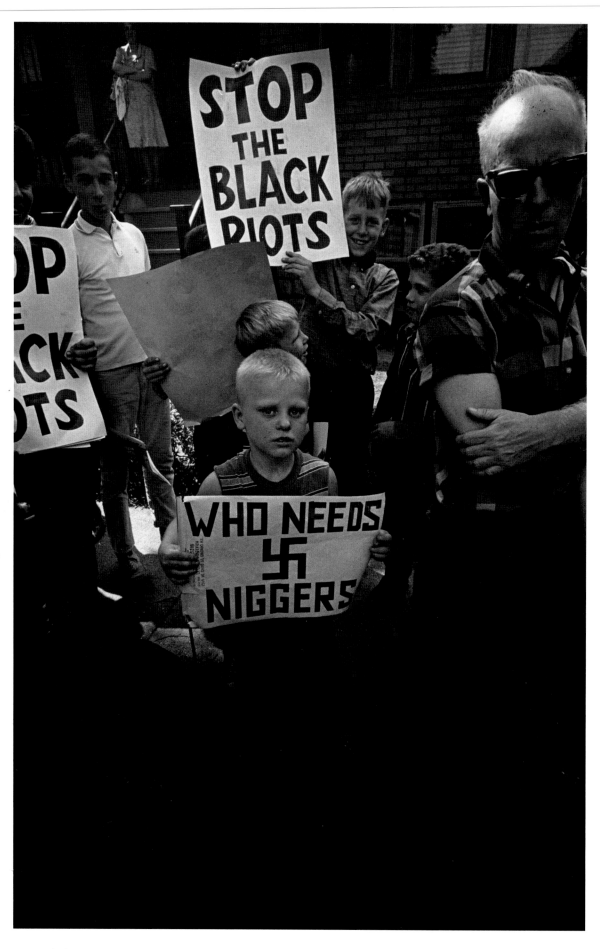

Anti-Black Demonstration, Chicago, 1966

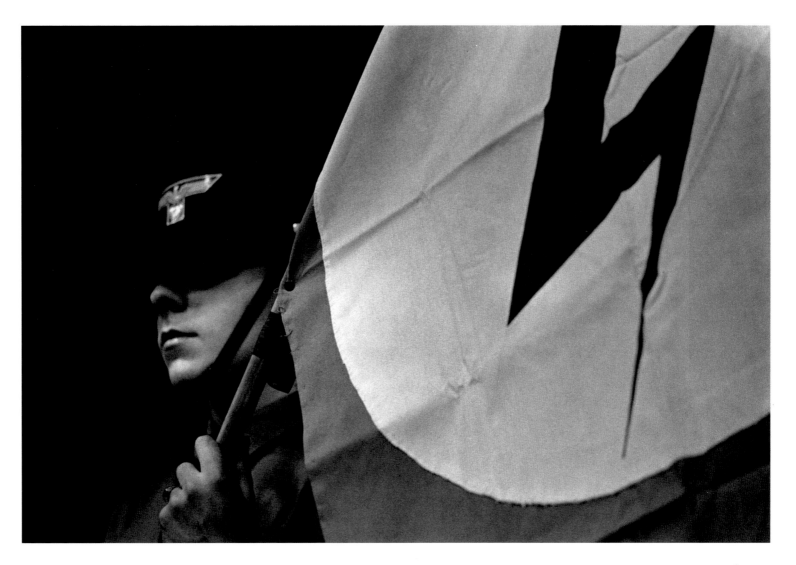

Neo-Nazi Demonstration, New York, 1966

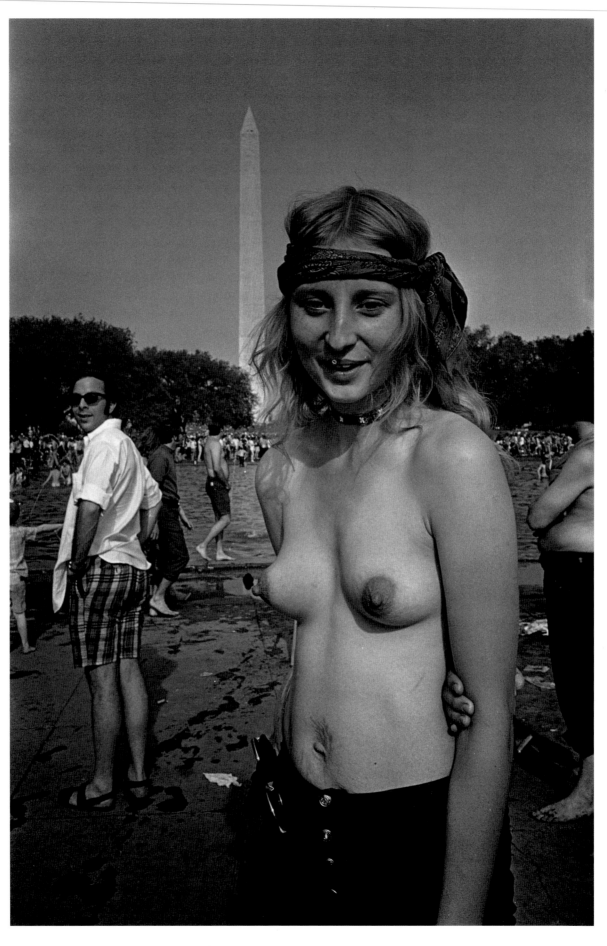

Anti-Vietnam-War Demonstration, Washington, D.C., 1969

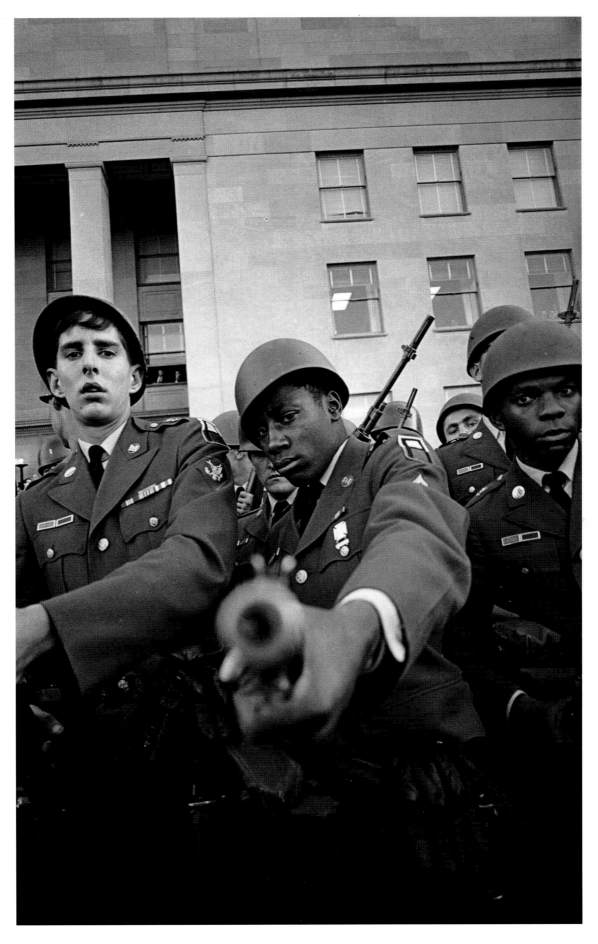

Pentagon Demonstration, Washington, D.C., November 1967

54

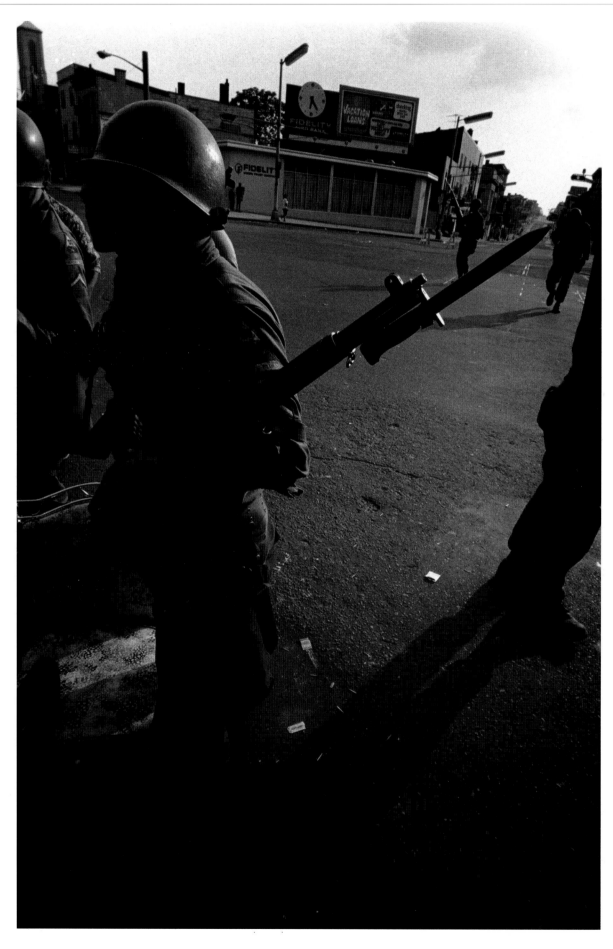

Black Riots, Newark, New Jersey, August 1967

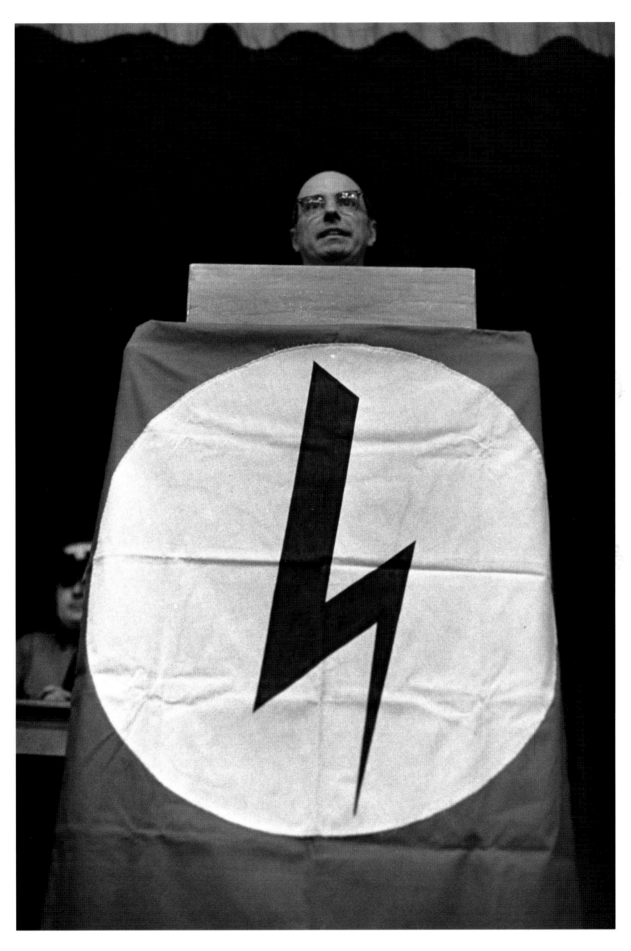

55

Neo-Nazi Leader, New York, 1966

Anti-Vietnam-War Demonstration, Washington, D.C., 1969

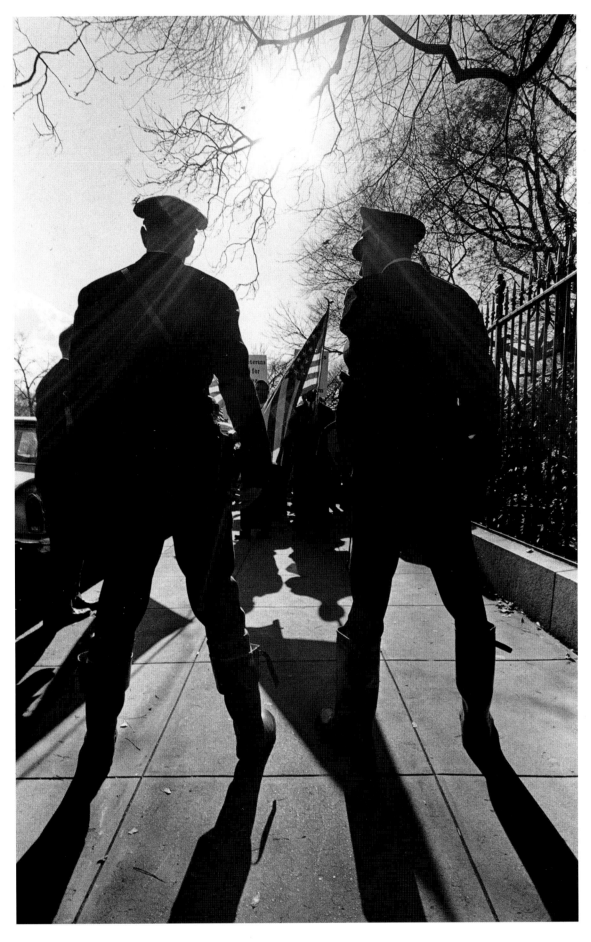

Veterans' Anti-War Demonstration, Washington, D.C., 1969

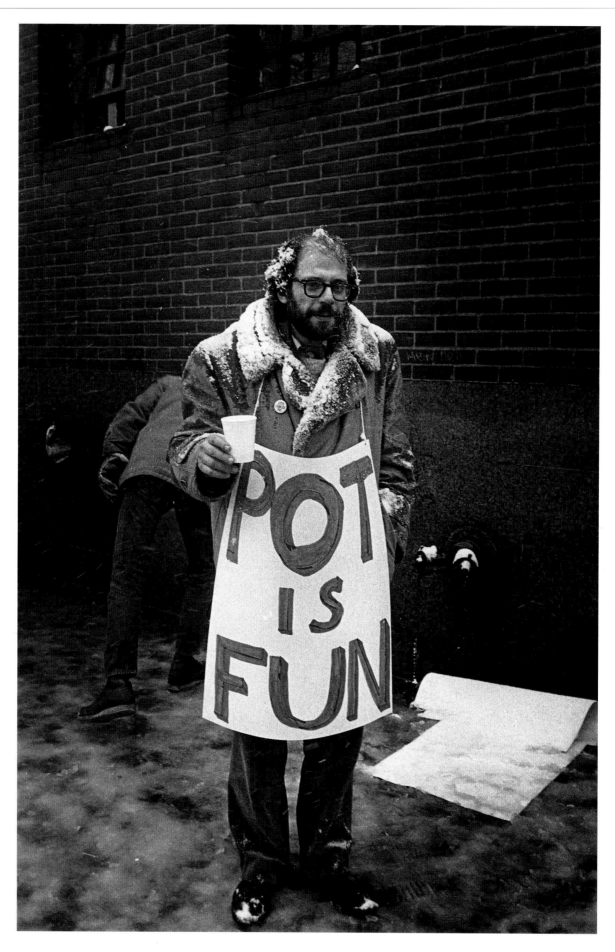

Allen Ginsberg Outside Women's House of Detention, New York, 1963

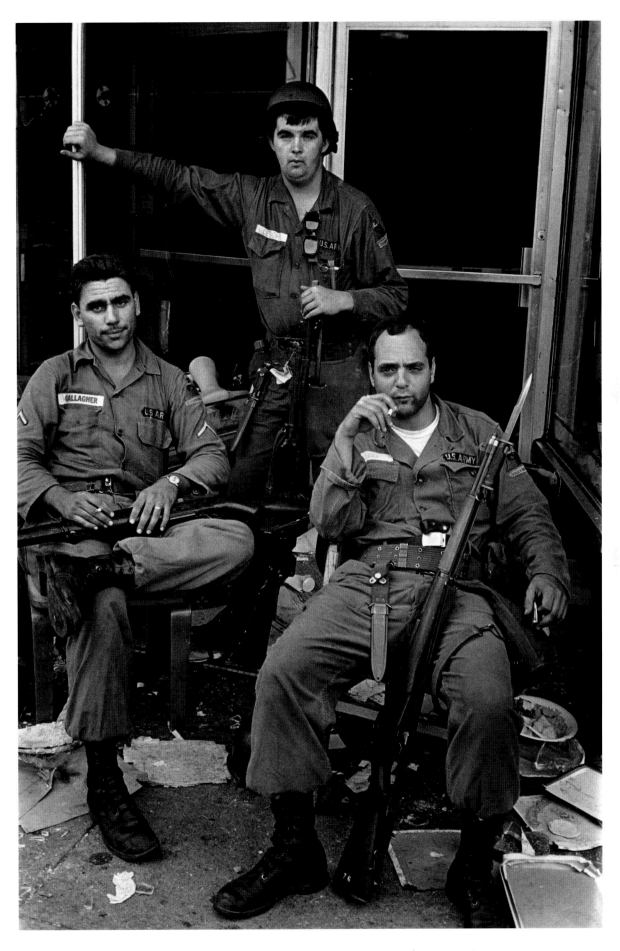

Rest, Newark, New Jersey, August 1967

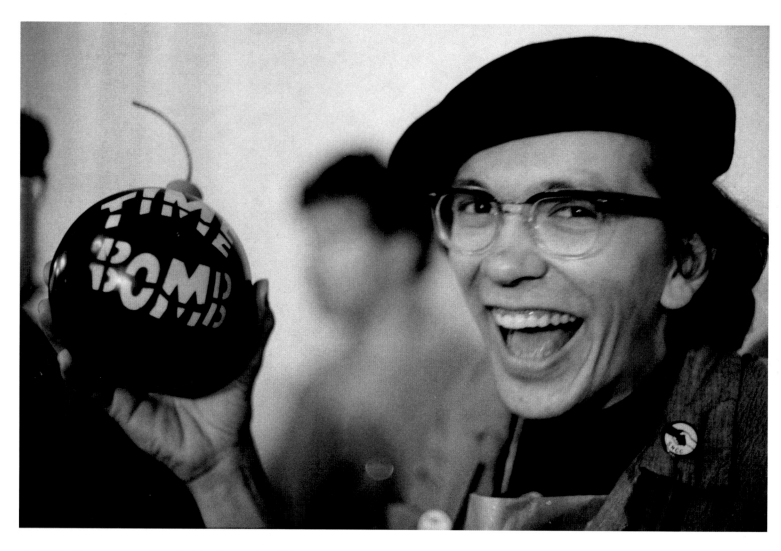

Anti-War Demonstration, New Politics Convention, Chicago, 1977

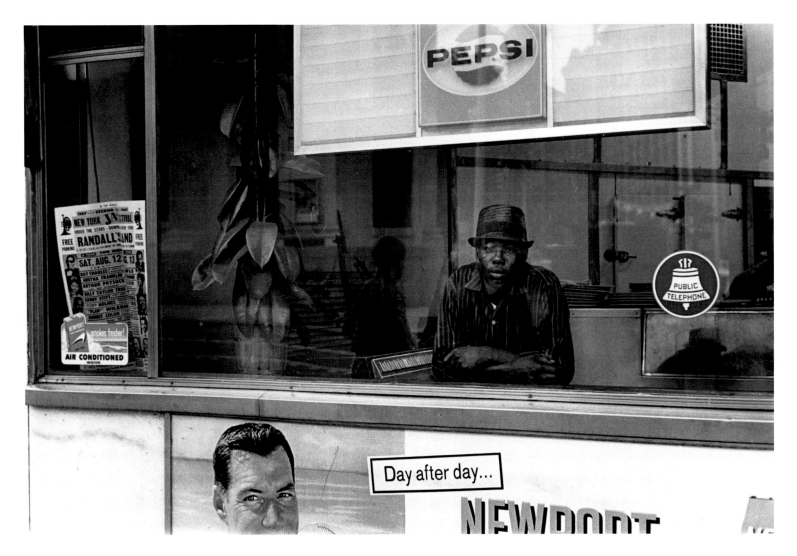

Black Riots, Newark, New Jersey, August 1967

Mental Poverty

New School, New York, 1969 / 70

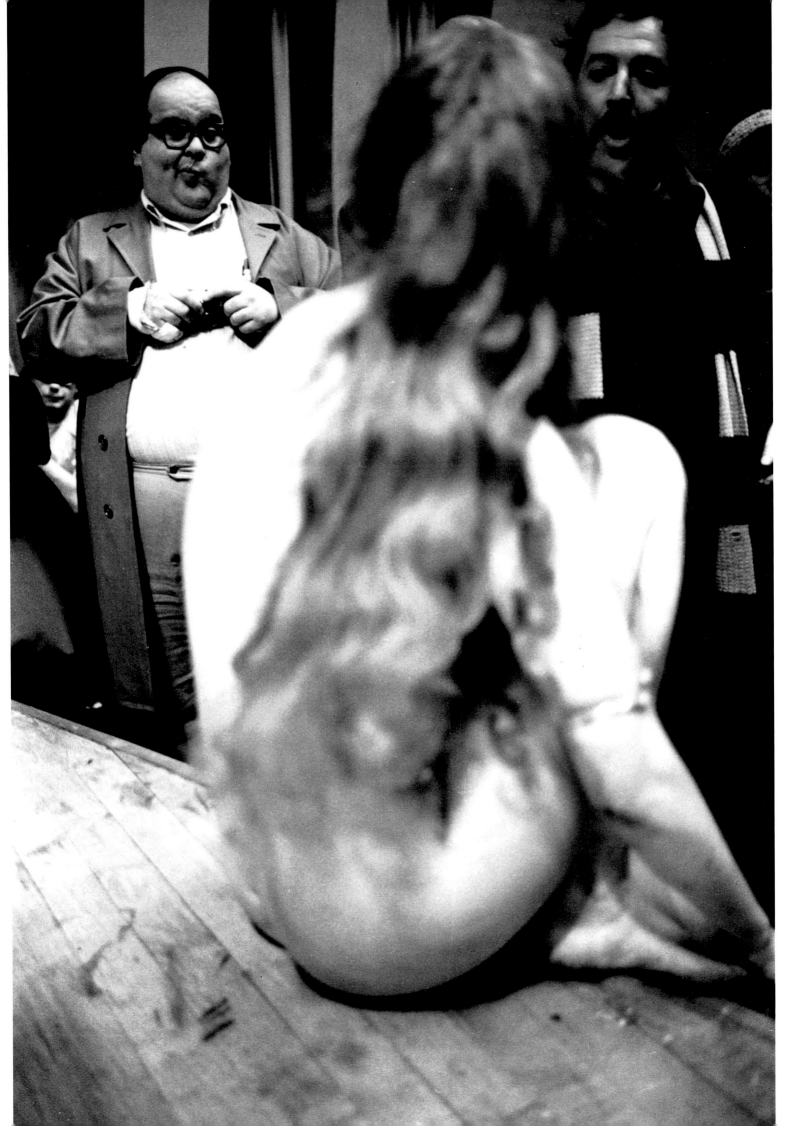

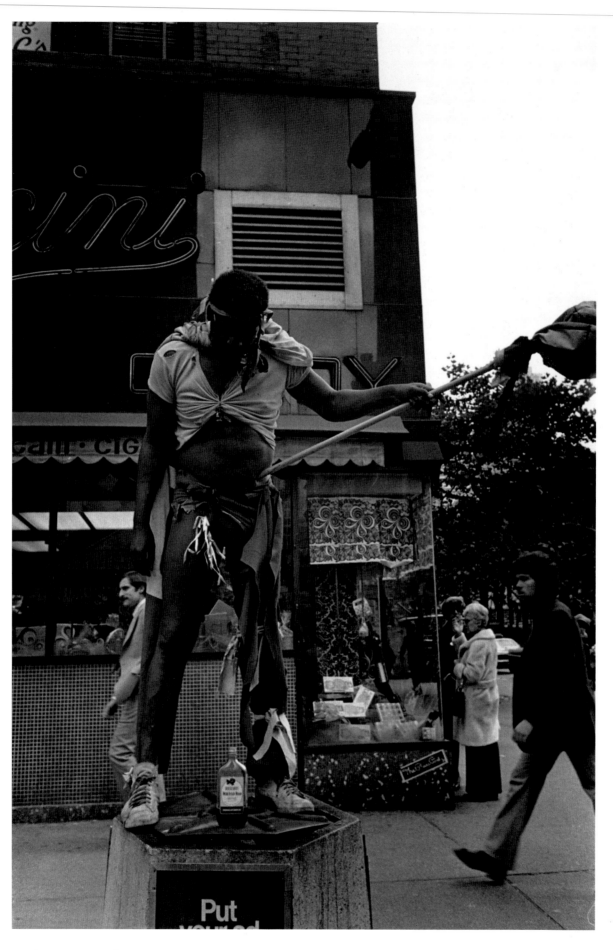

42nd Street, New York, 1975

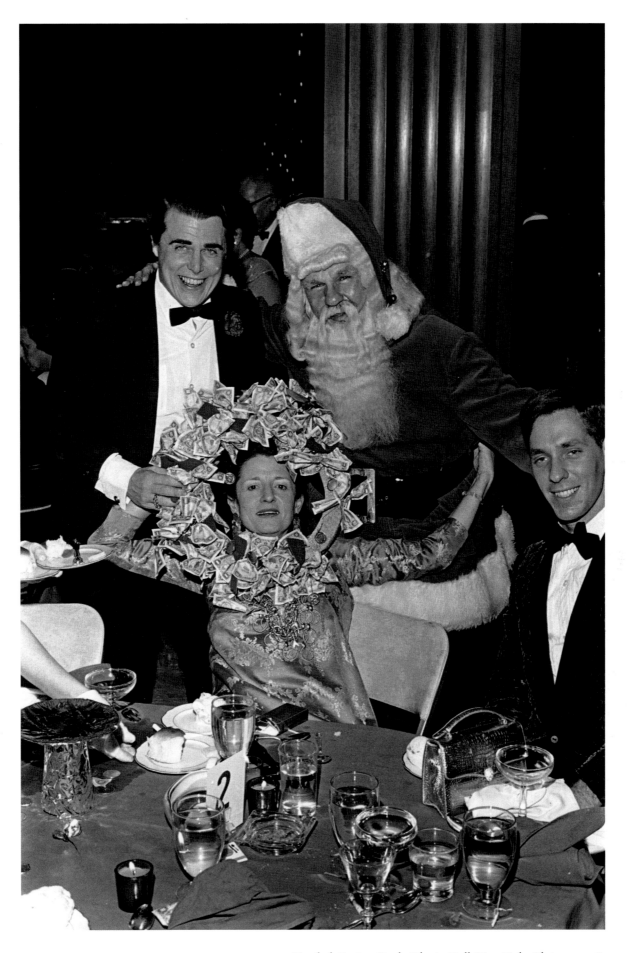

Drydock Savings Bank, Charity Ball, New York, Christmas 1967

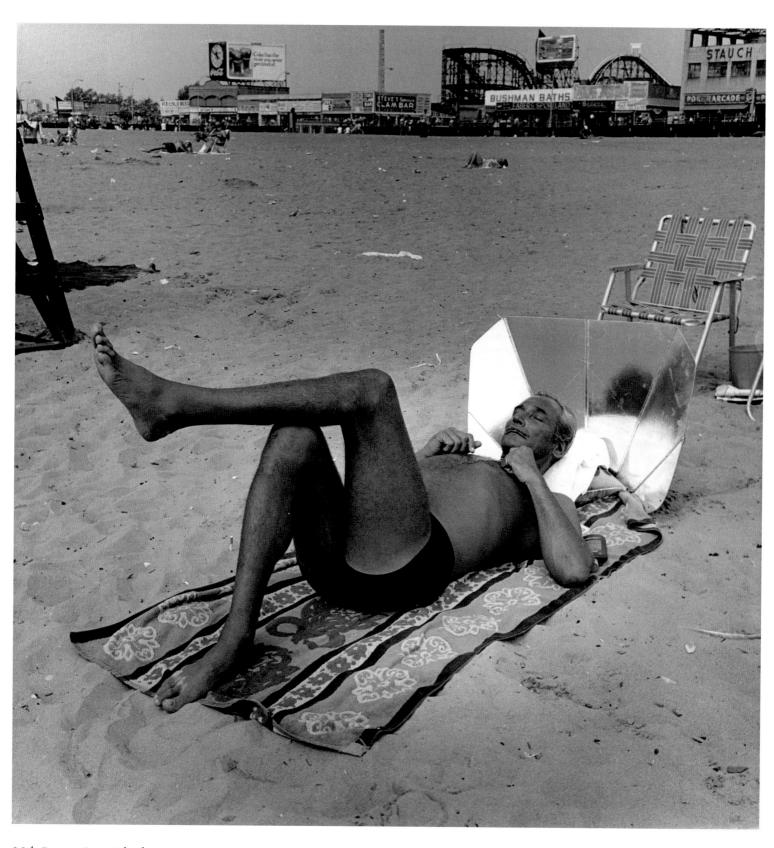

Male Beauty, Coney Islands, 1970

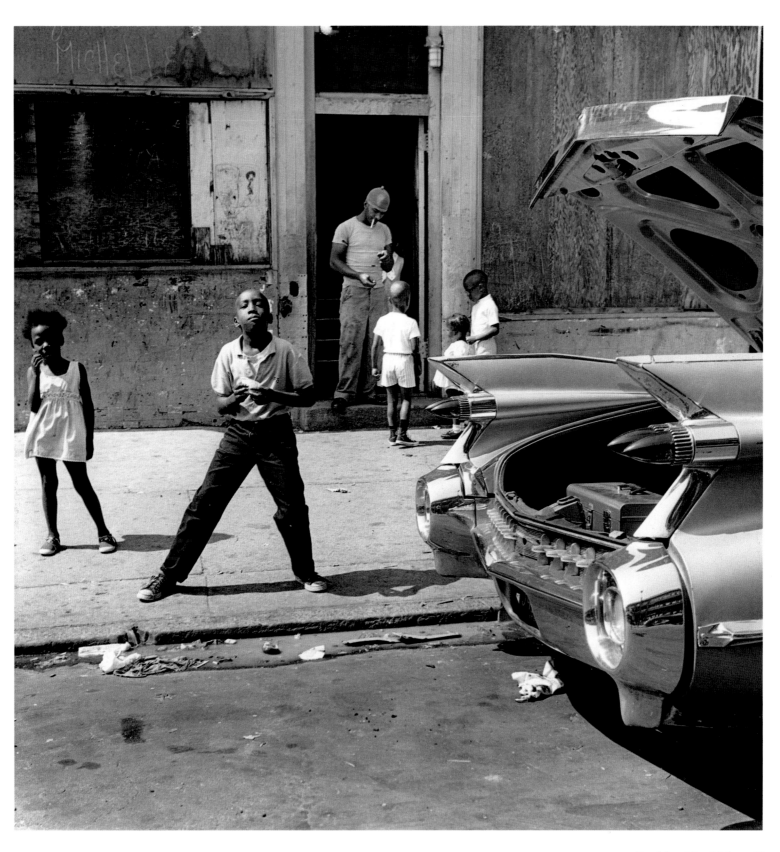

Brooklyn, New York, 1968

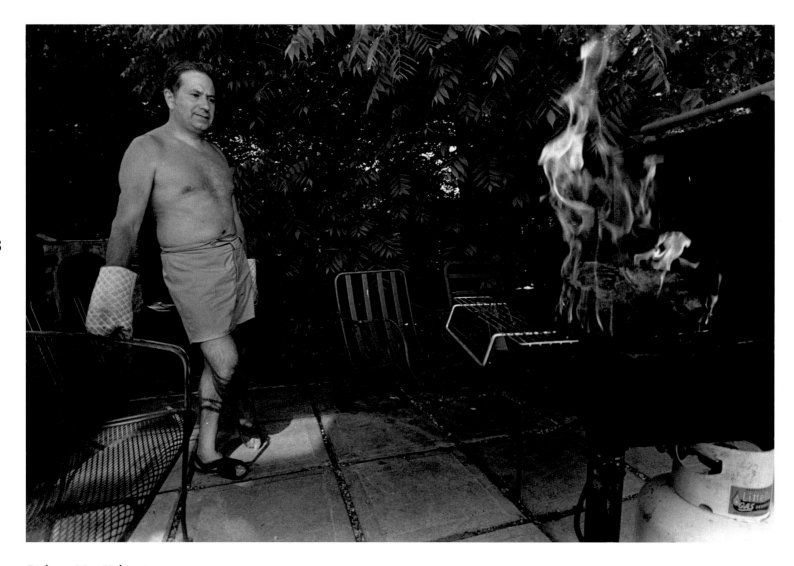

Barbecue, New York, 1984

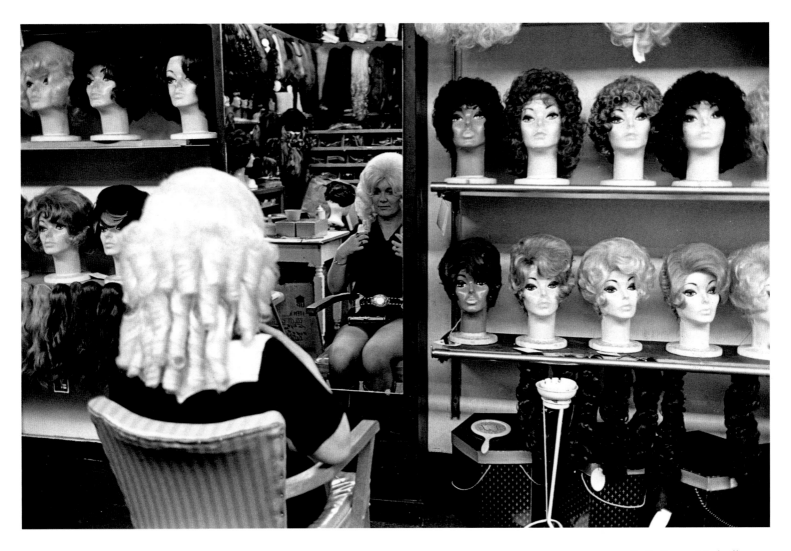

Dolly Parton, Nashville, 1979

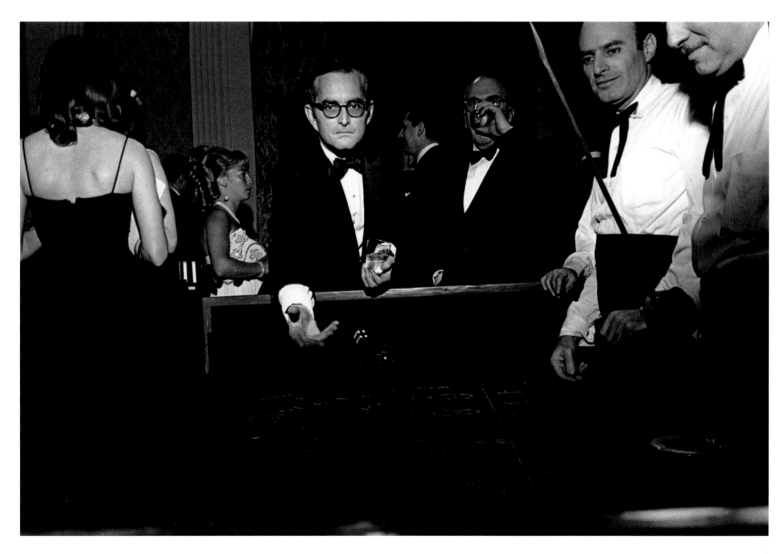

California, August 1966

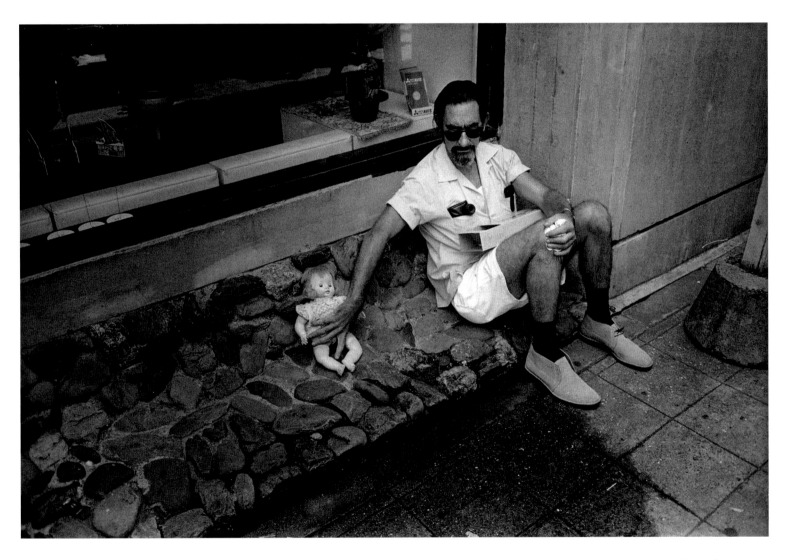

Kyoto, Japan, 1973

Bikers

Daytona Beach, Florida, 1986

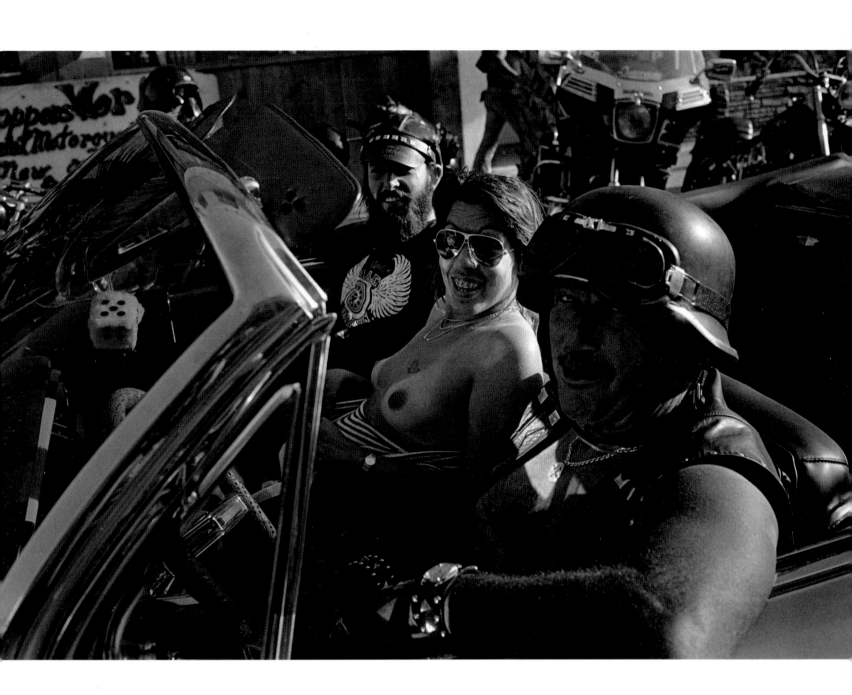

Boot Hill Saloon, City of Daytona Beach, 1988

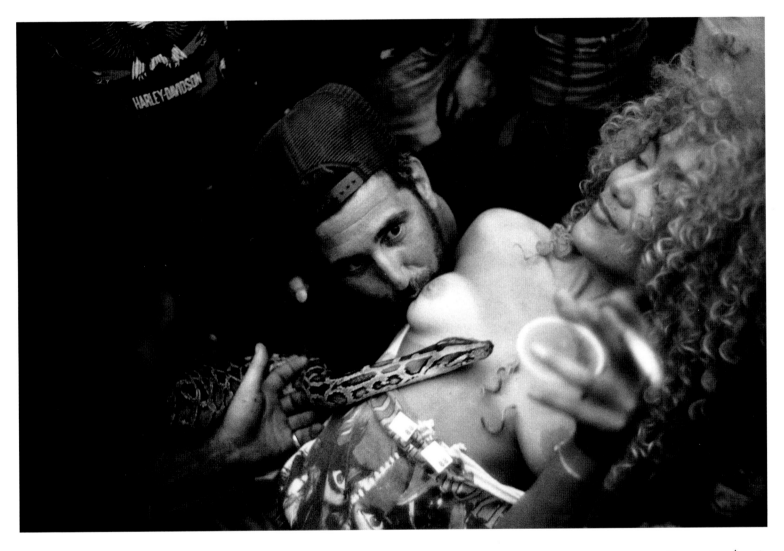

Daytona Beach, 1989

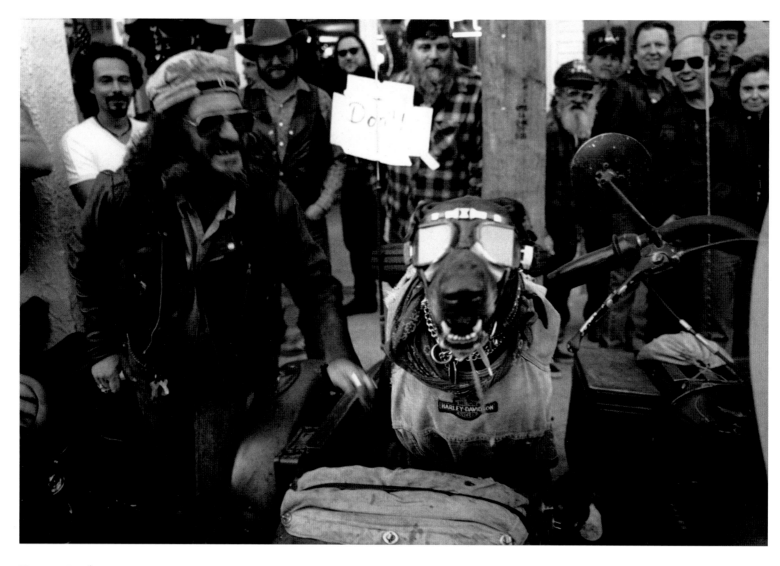

Daytona Beach, 1986

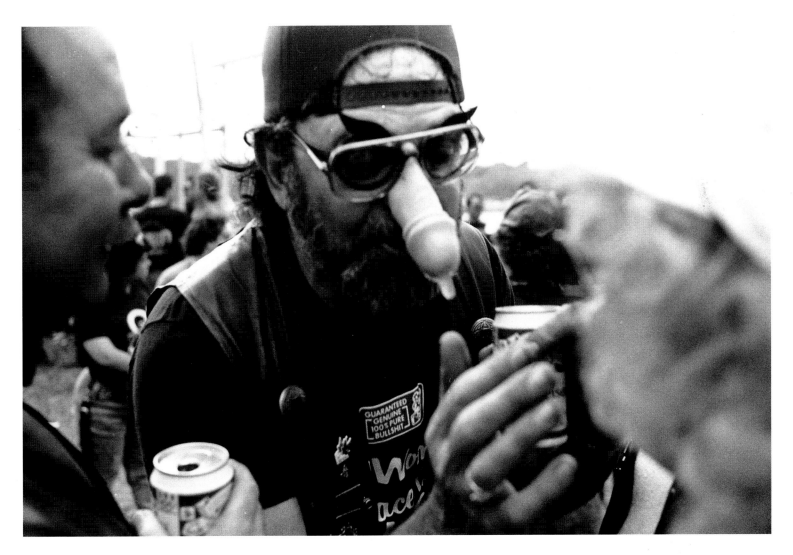

Pub 495, Daytona Beach, 1986

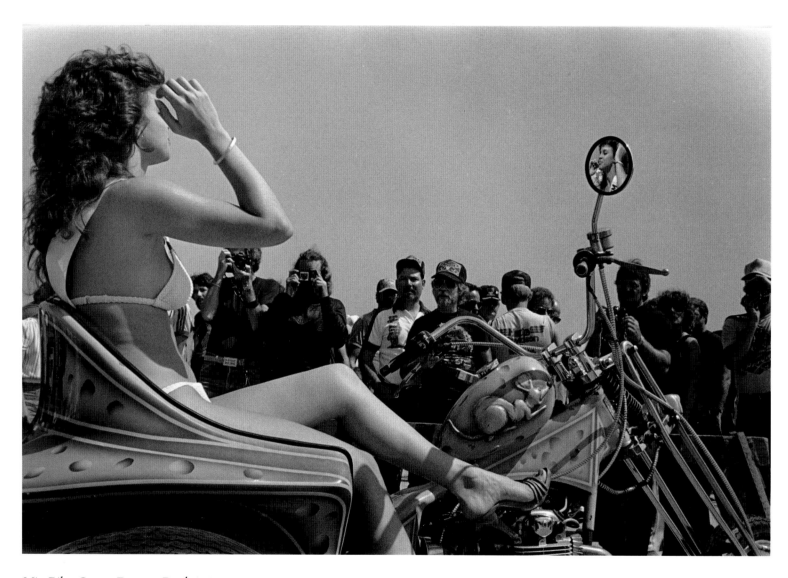

Miss Biker Queen, Daytona Beach, 1987

Mud Wrestling, Daytona Beach, 1989

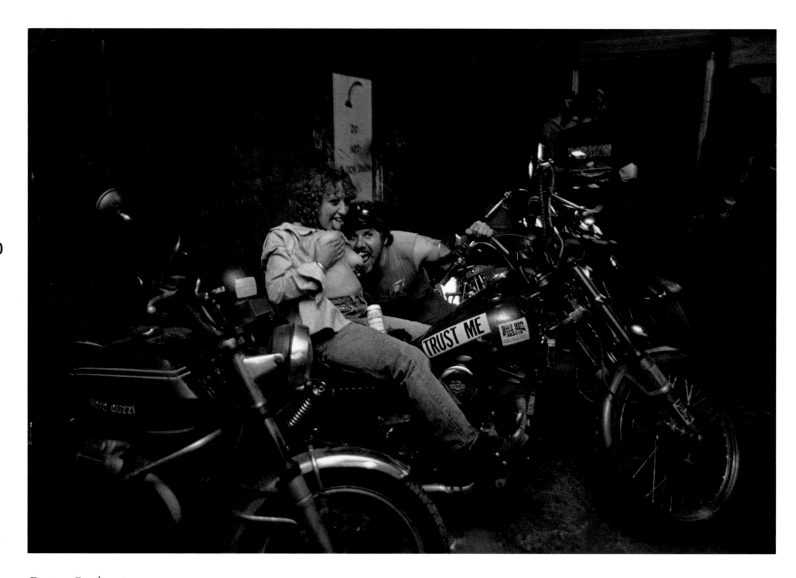

Daytona Beach, 1985

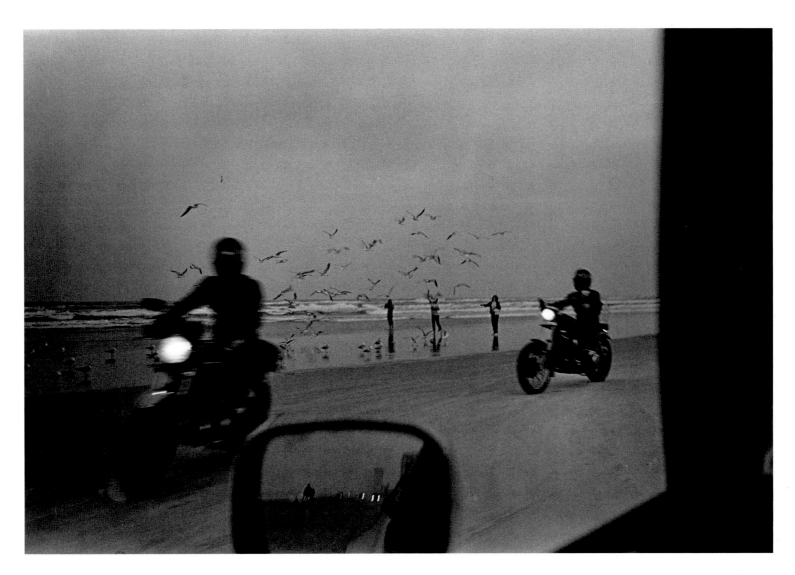

Daytona Beach, 1989

Puerto Rico

Man in a White Suit, Puerto Rico, 1976

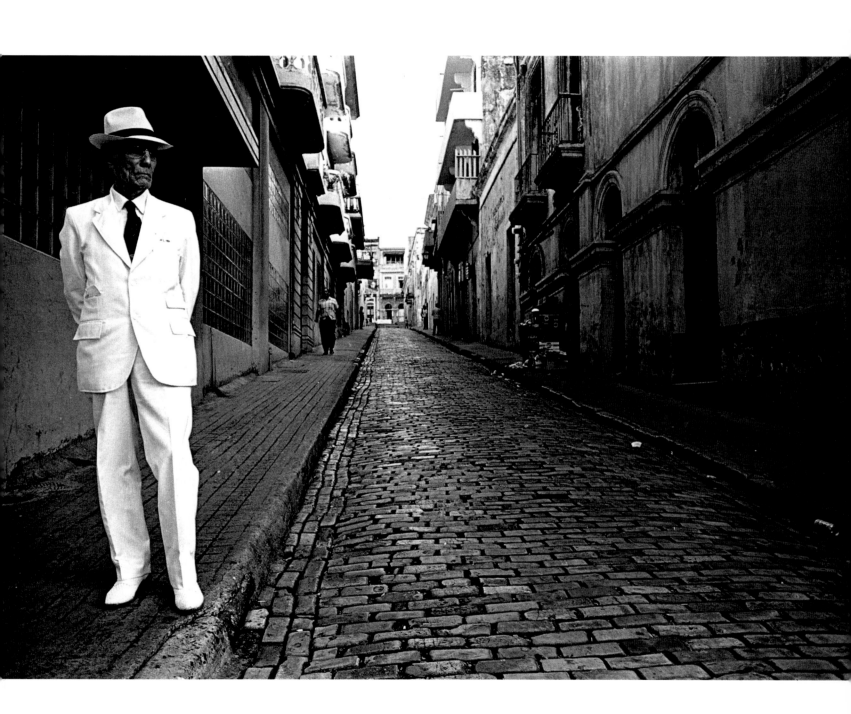

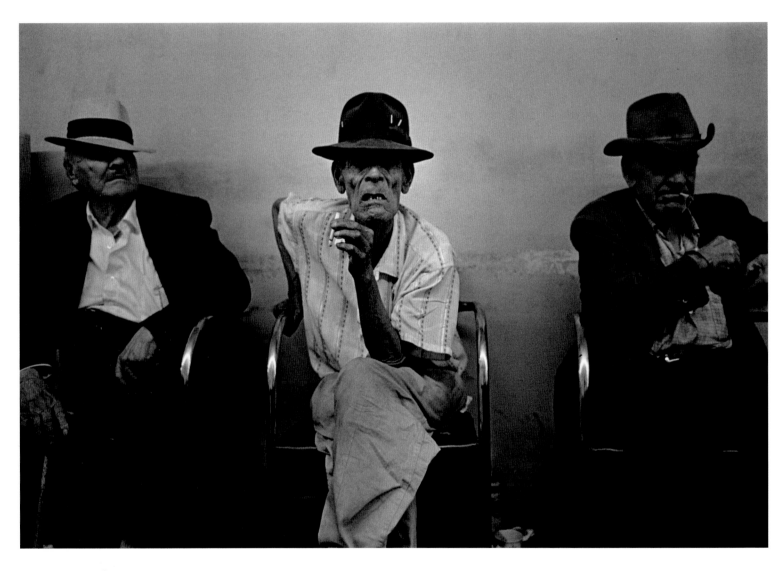

Puerto Rico, 1976

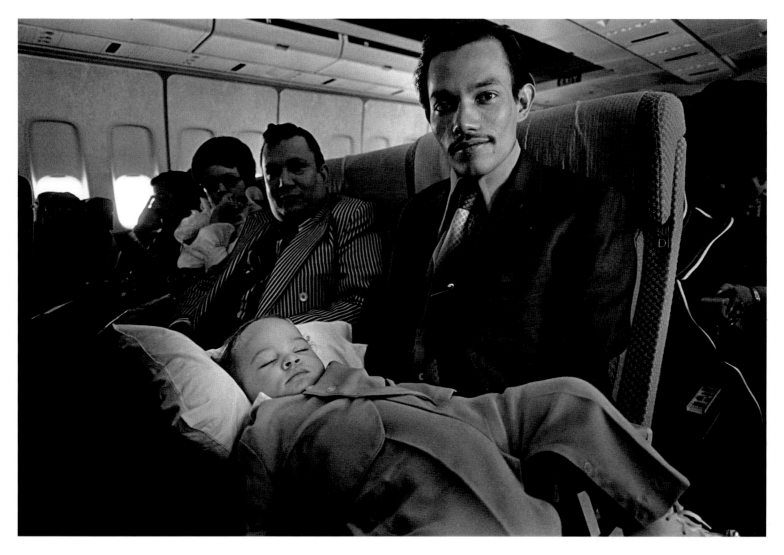

Flight to Puerto Rico, 1976

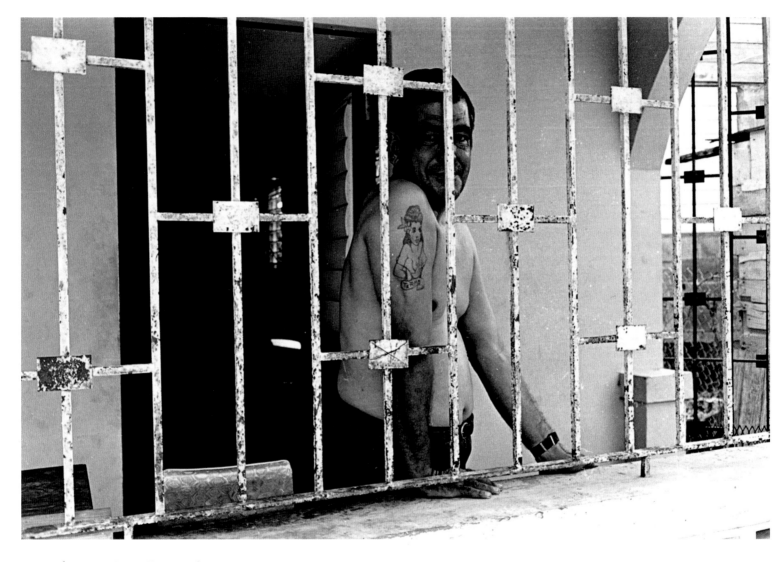

Man in his Home, Puerto Rico, 1976

Puerto Rico, 1976

Tatoo, Puerto Rico, 1976

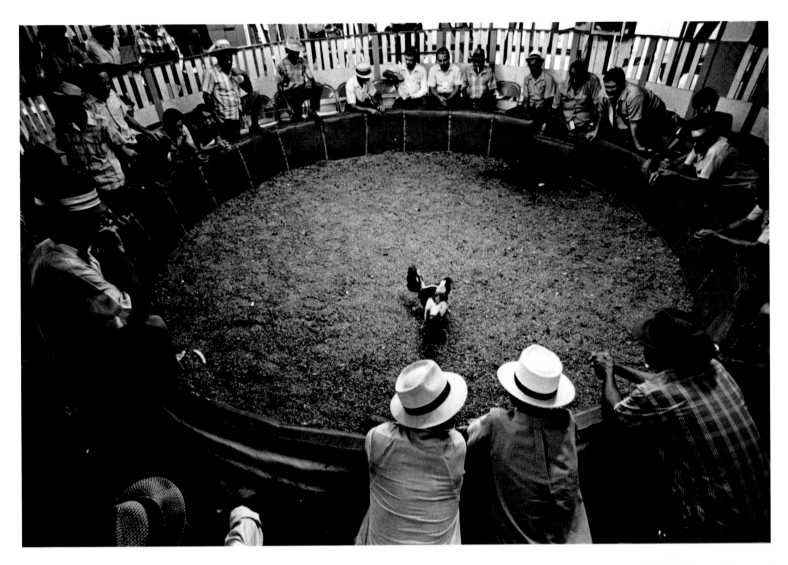

Cockfight, Puerto Rico, 1976

Three Boys, Puerto Rico, 1976

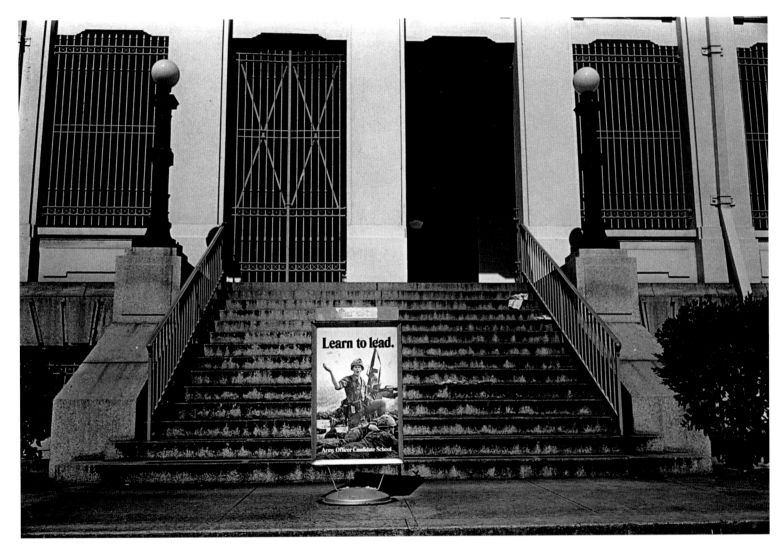

Post Office, Puerto Rico, 1976

Industry

Hatachi Shipyard, Osaka, 1970

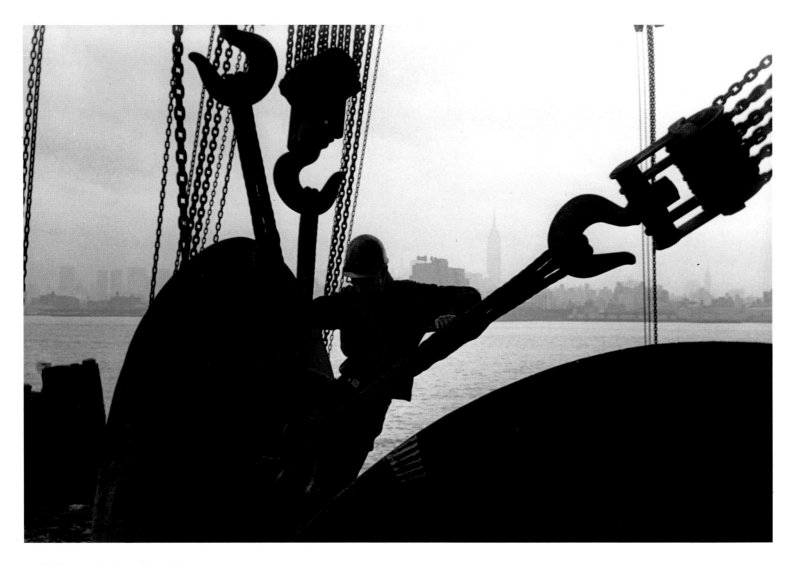

Bethlehem Steel Shipyard, Hoboken, New Jersey, 1969

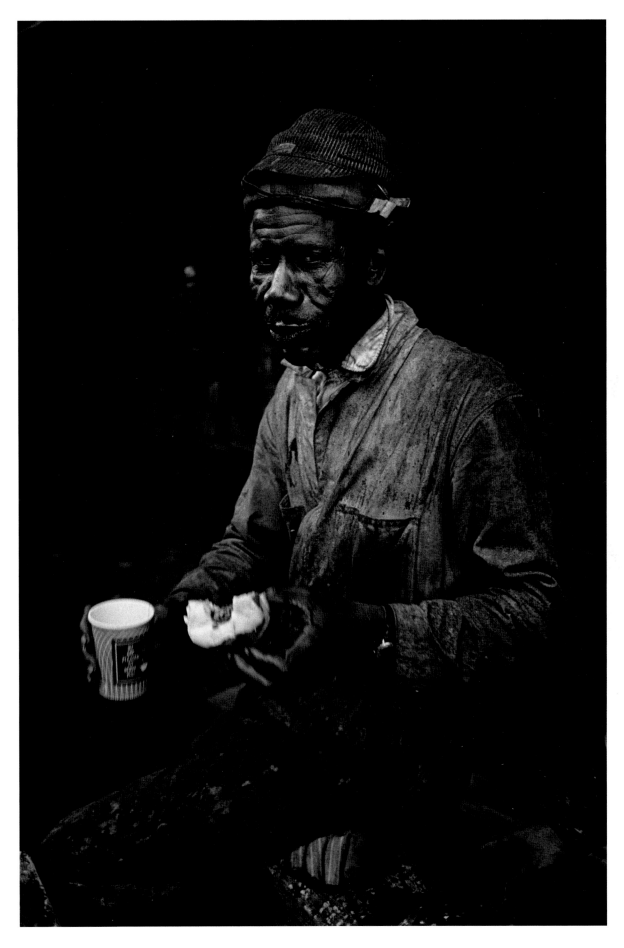

Worker, Hoboken, New Jersey, 1969

Ellis Island, Locker Room, 1969

Ellis Island, 1969

Ellis Island, 1969

Ellis Island, 1969

China

Tai Chi, Shanghai, 1982

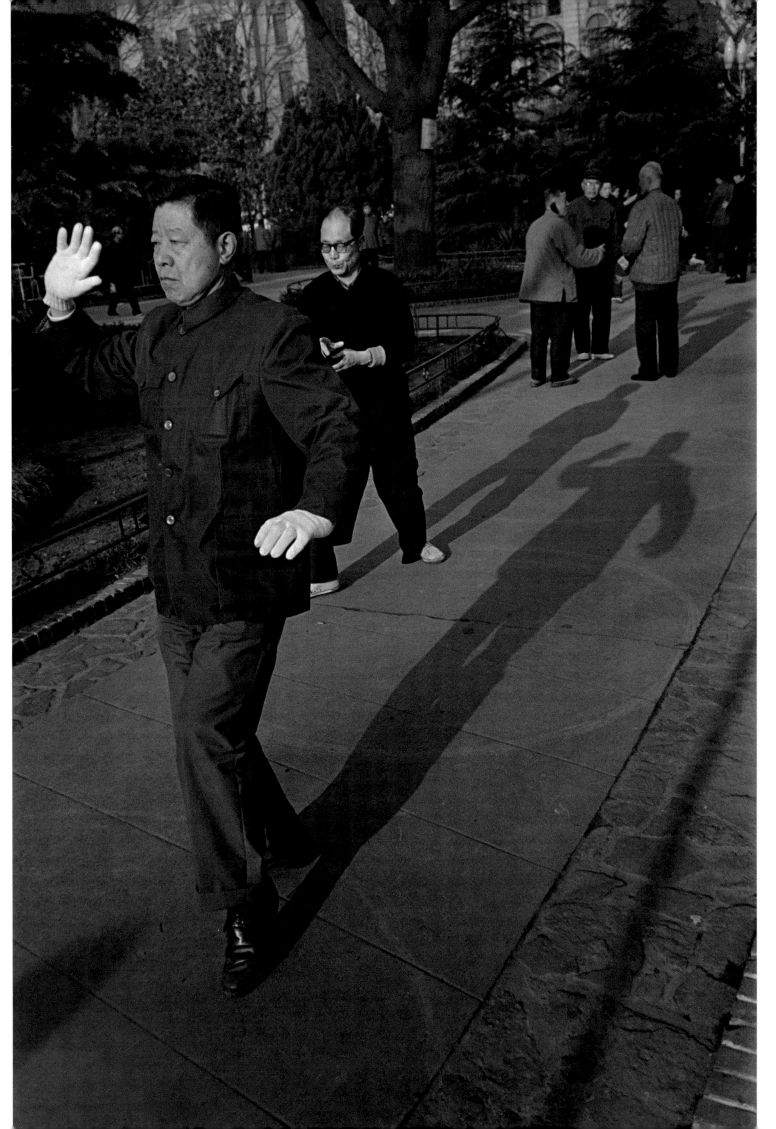

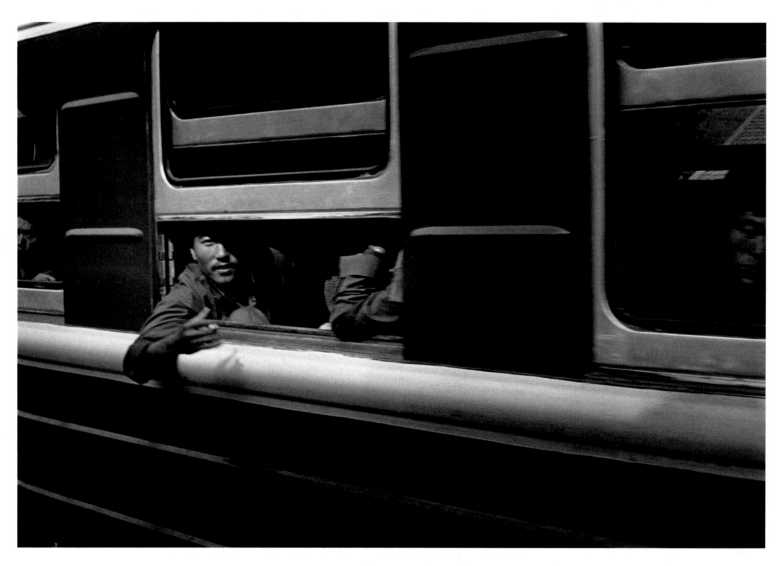

Railway, 1986

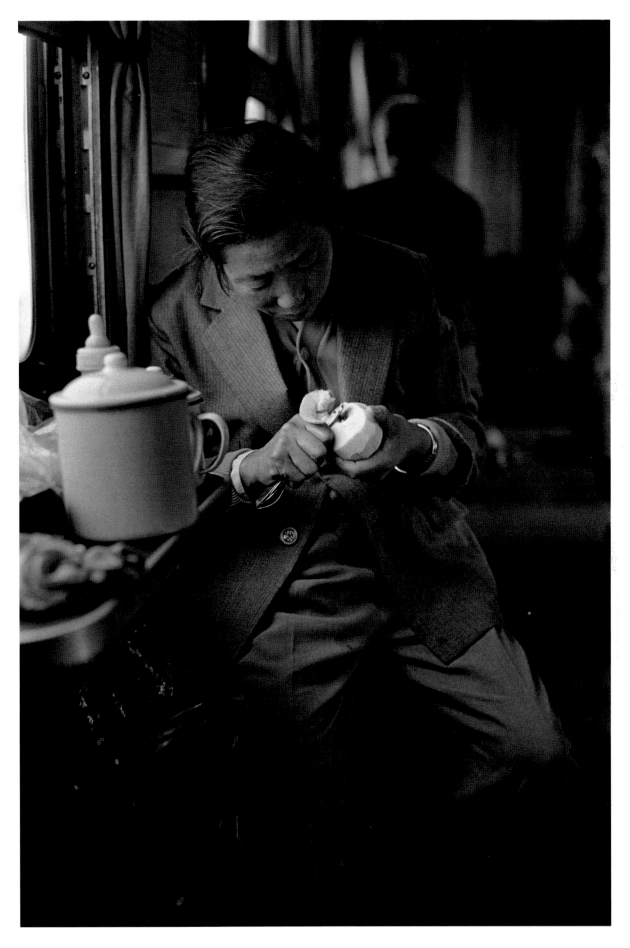

Railway, 1986

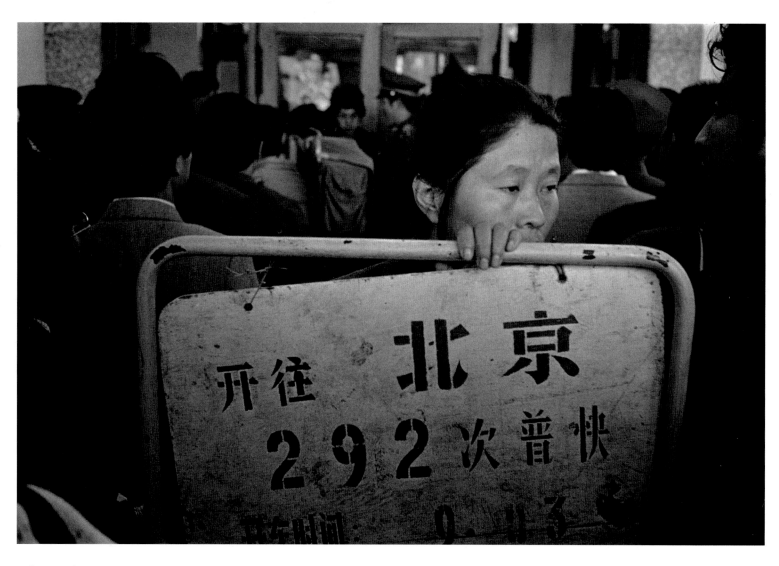

Peking Railway Station, 1986

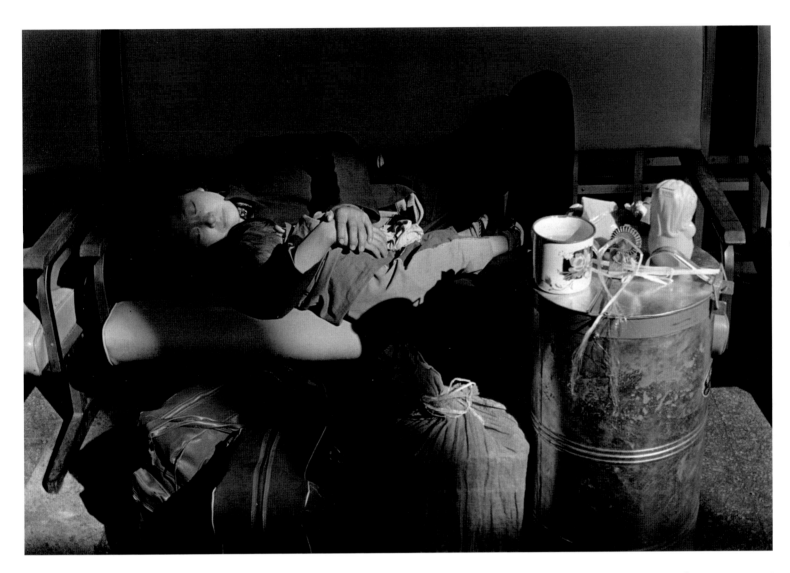

Peking Railway Station, 1986

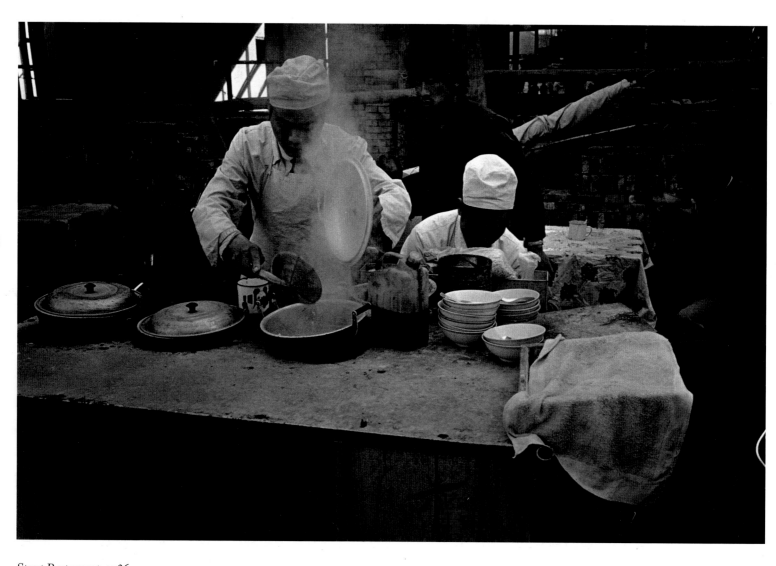

Street Restaurant, 1986

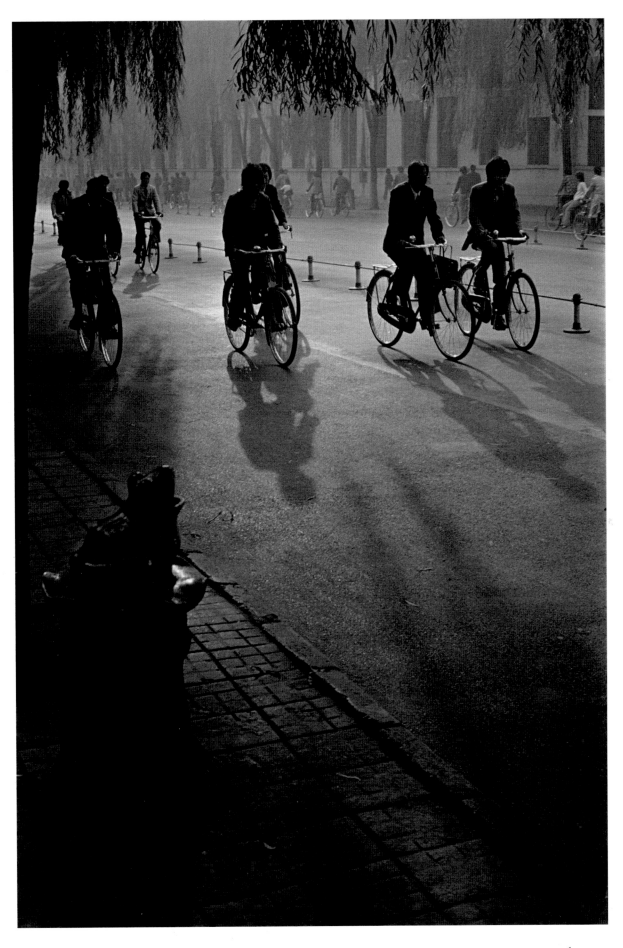

Quelin, 1982

108 Japan

Dance Academy, Tokyo, 1970

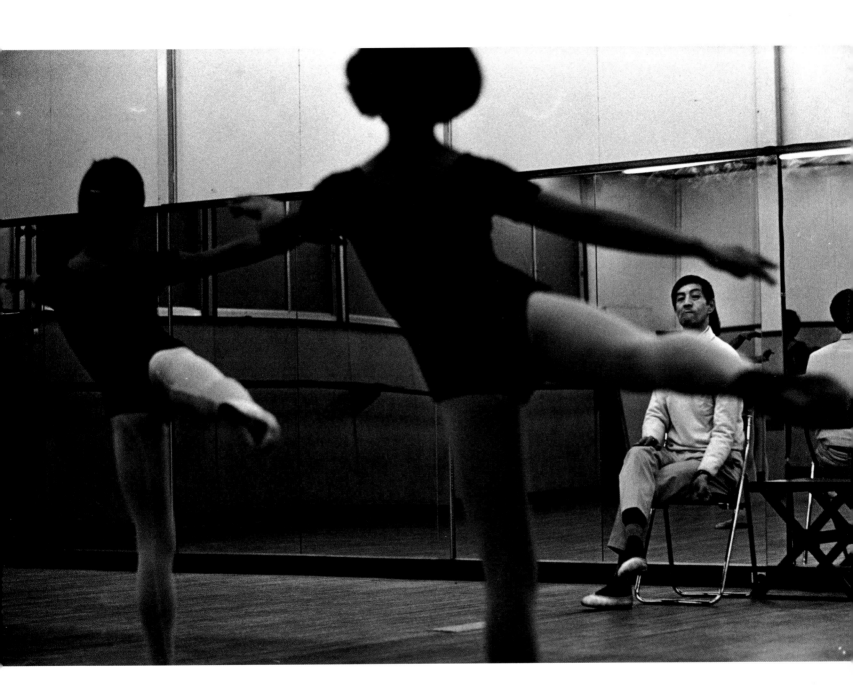

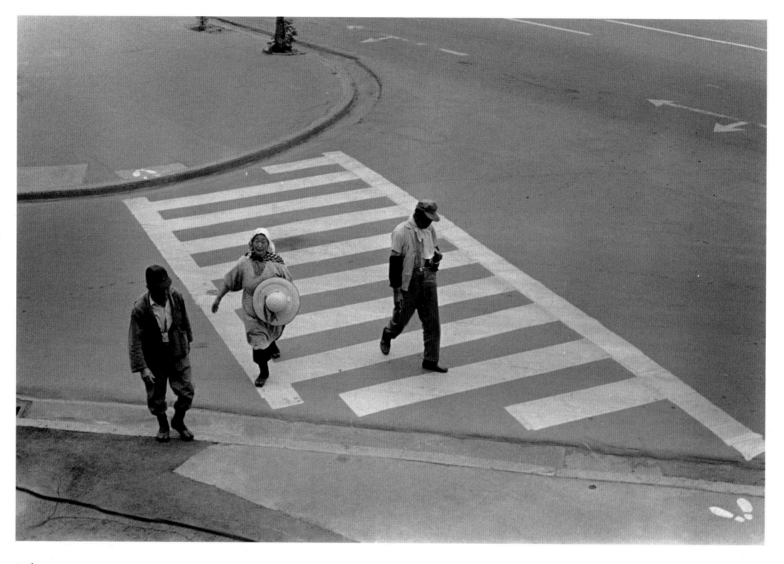

Tokyo, 1973

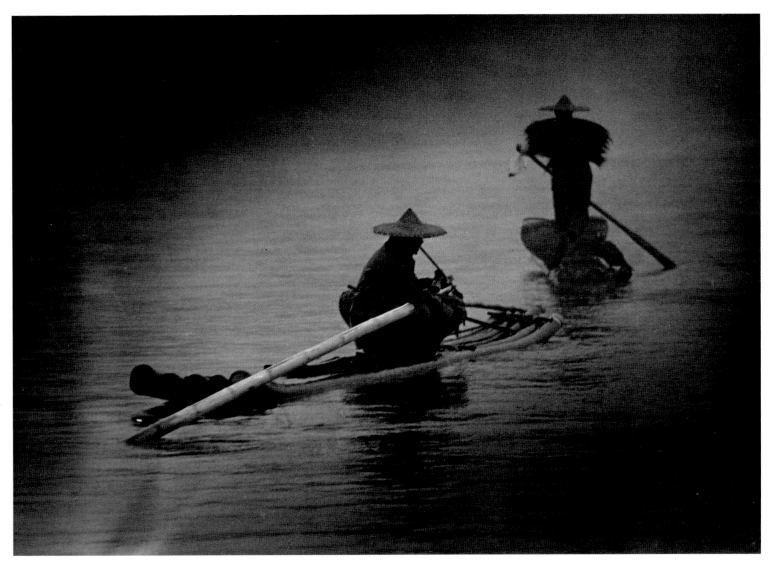

Fisher, 1982

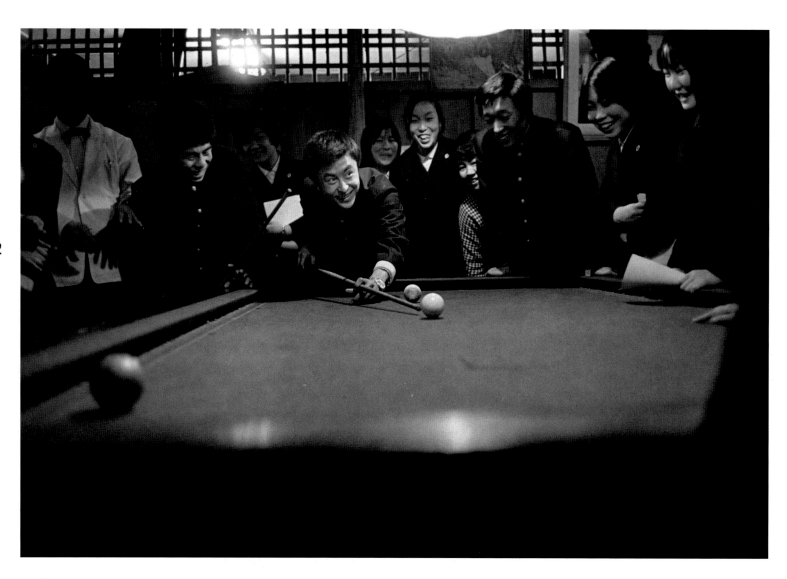

Students, Nicombe, 1986

Subway Station, Tokyo, 1970

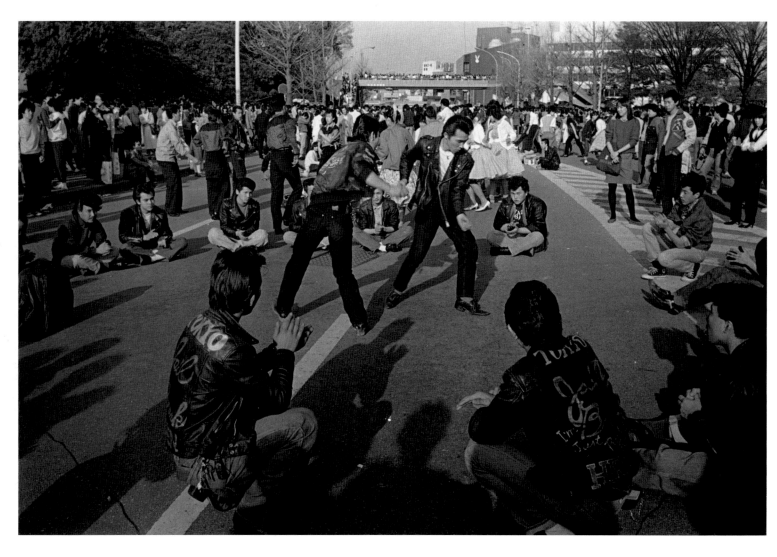

Park, Tokyo, 1986

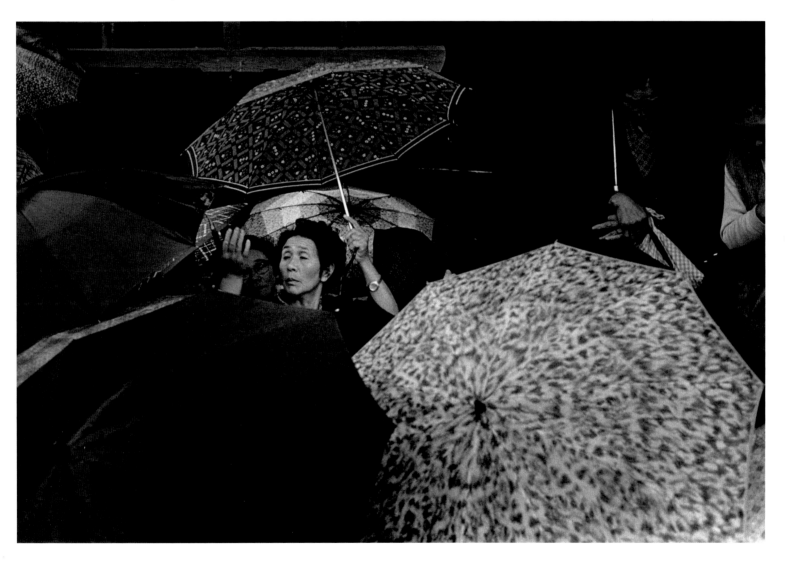

Valley of the Dead, Han Tschu Island, 1973

Moscow

Red Square, Moscow, 1990

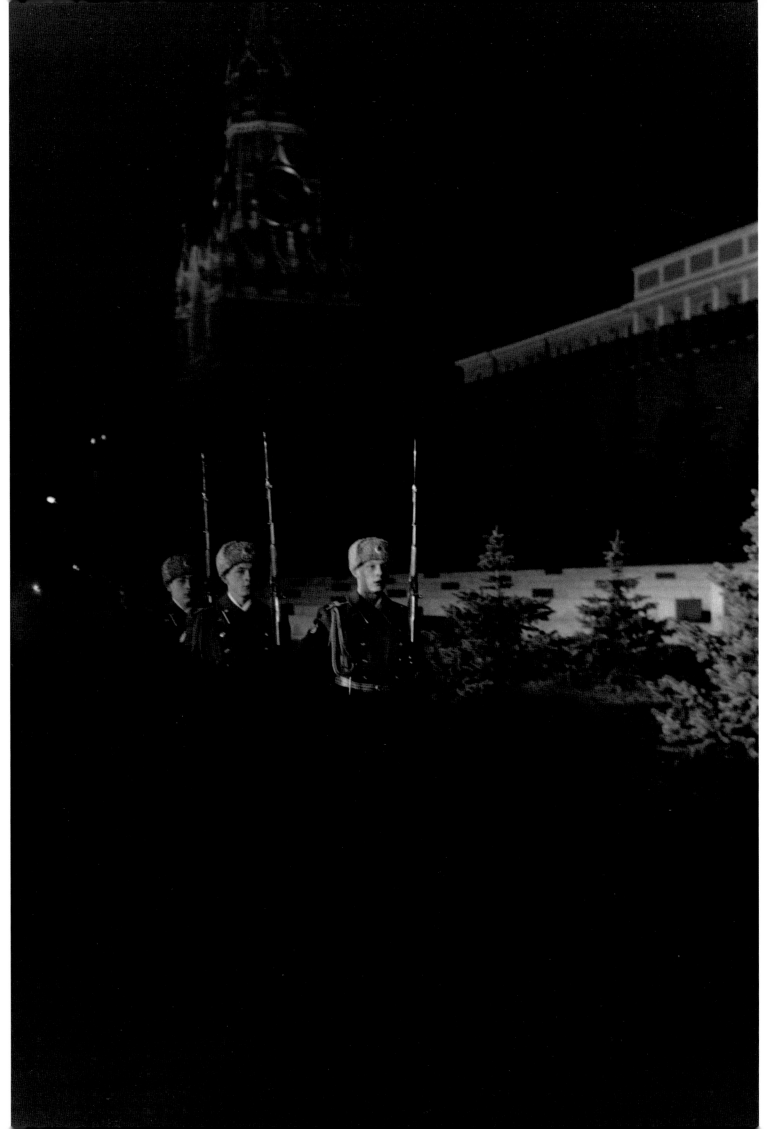

Park, Moscow, 1990

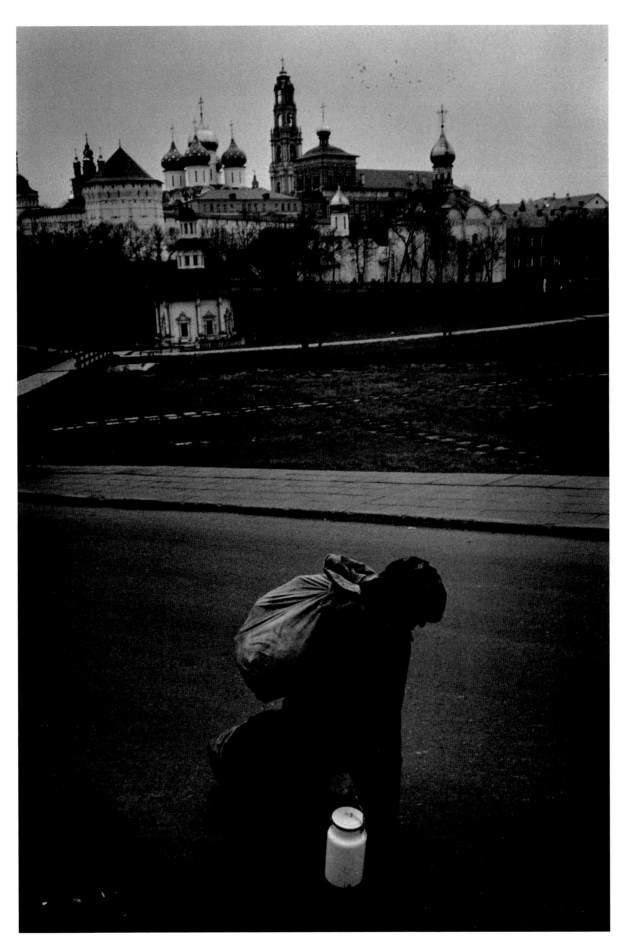

Kremlin, Moscow, 1990

120 Speaker's Corner London

Speaker for Socialist Party, London, 1975

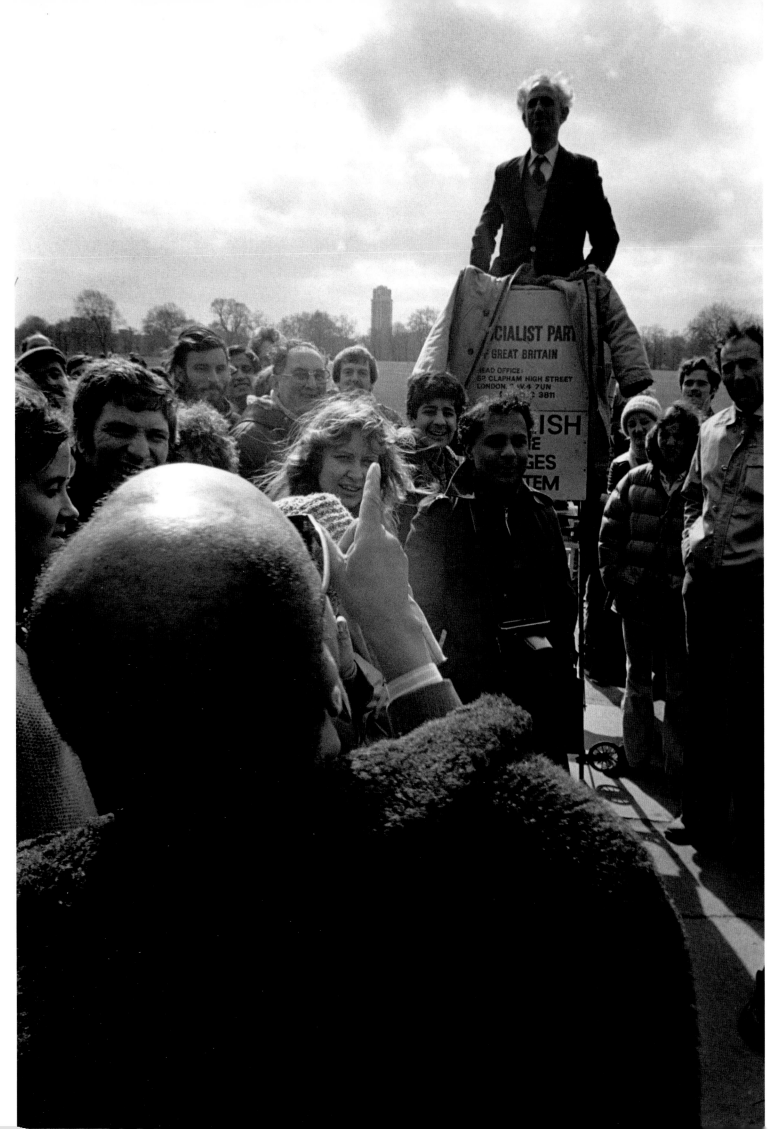

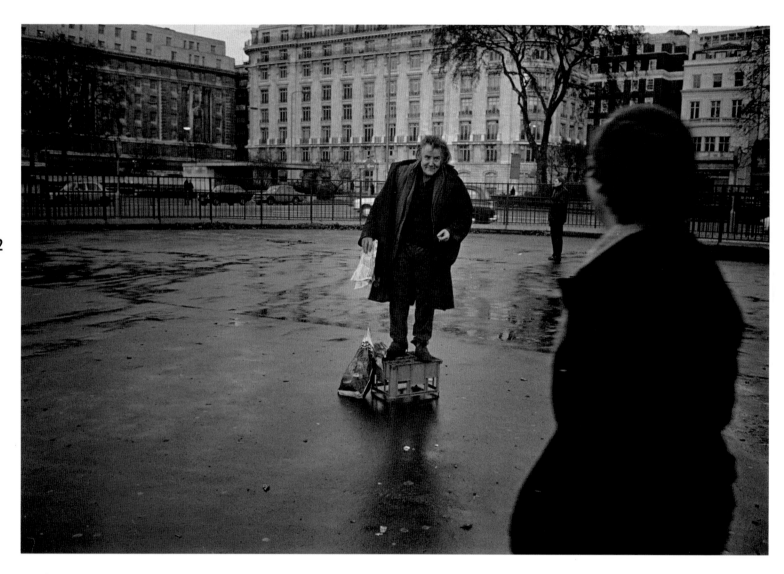

Speaker, 1975

Speaker, 1982

124 Portrait

Bill Clinton, UN, New York, 1995

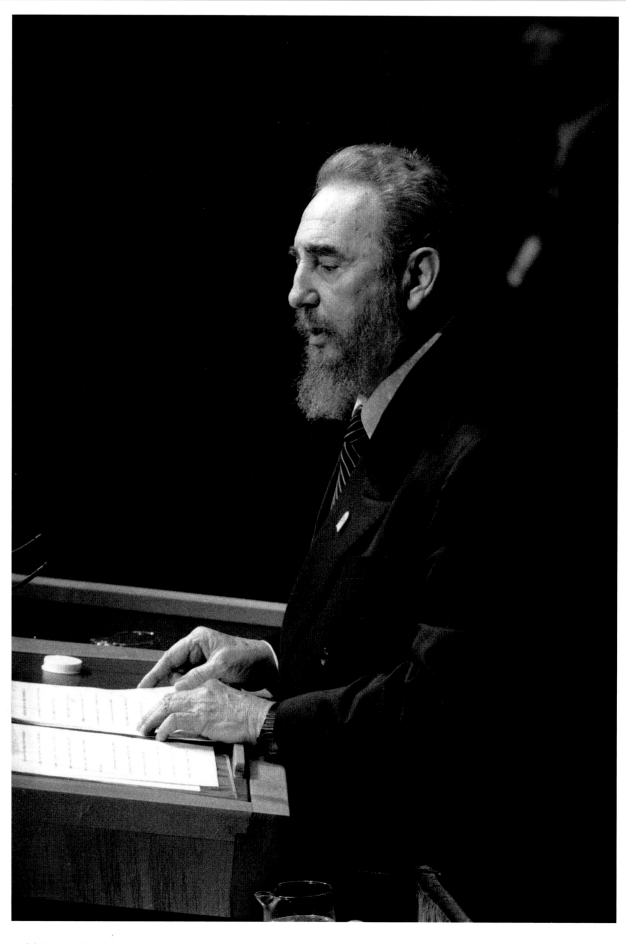

Fidel Castro, UN, New York, 1995

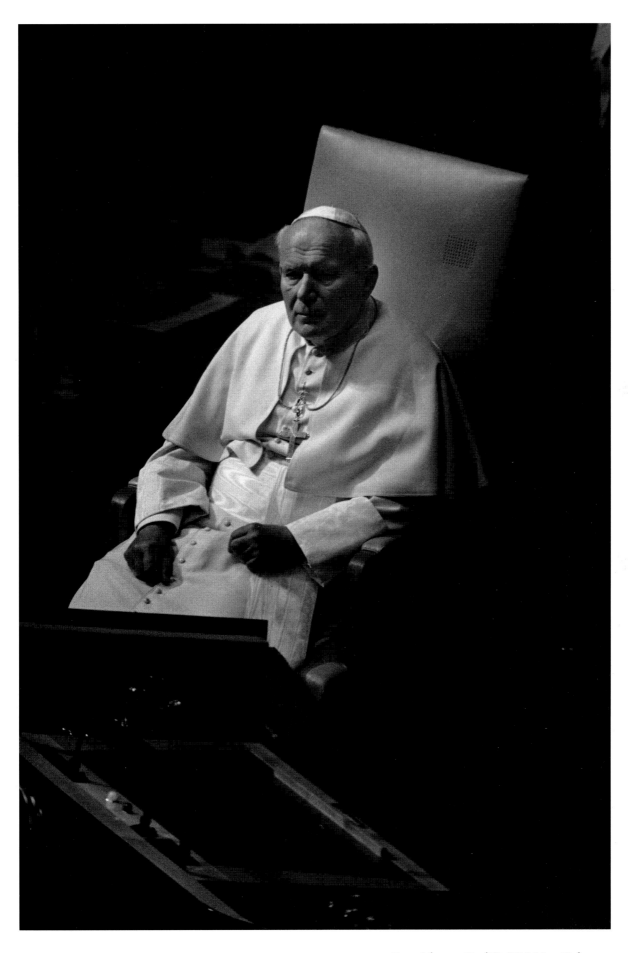

Pope Johannes Paul II., UN, New York, 1995

"When I work, I am a different person"

Gerald Koeniger talks with Ben Fernandez

Gerald Koeniger: Ben, in some phases of your "camera at work" I see a special kind of role-playing – in your transvestites, in your cooperation with Joseph Papp's Public Theater, in your series on the Bikers in Daytona Beach and in your various photographs of the public and the political stage. What is your own role in this interplay?

Ben Fernandez: If you look at my protest material – because it is easy in the sense of negative/positive – then you can see that I try to walk between the two, to give you the opportunity to take your own position. And if you look through all of my work you will see that I have always tried to do this. Now I've come to understand that the viewer has to bring in his own experiences and that my photographs trigger points of excitement. For example, when the ultra-rightists or Neo-Nazis see my work on them they love the idea that I depict them as strong, as someone to be feared. And so they think I believe as they do, and they welcome my participation. That is because I make the Nazis look strong and powerful. On the other hand, the left looks at my work and also believes I am sympathetic. My photographs represent them as understanding, looking for reason and moderation, and they interpret my photographs of the Nazis as strong, powerful and stupid. And the Nazis view my photographs of the left as weak, incapable of making a decision and divided in direction.

If you give people room to act out their own imagination you have to be aware that taking pictures is also a process of making decisions. Where do your own ideas fit in when you're trying to visualize theirs?

I guess what dominates my own imagination is the idea that fairness and justice for all people will always prevail. But I have learned that this is not true, that private agendas and hidden positions will always tip the balance away from fairness.

Do you think at the limits of games, of experiences, of chance?

Life, I have come to perceive, is a gamble. And I have found that photography is excellent for this reason. The main structure of photography is that you take a negative image projected with light and you make it positive.

What do you think is the relationship between gambling and learning by experience? Because I think you always had a vision.

Indeed, I always had a vision. In order to gamble, you must have something to wager. In most people's lives, they go to school, they study and they come to certain conclusions. For myself, school was a difficulty. Unbeknown to me and my parents and teachers I had a malady. It was diagnosed as dyslexia.

Is photography your way of reading the world?

Yes, you can say that. For me it was naturally necessary to become visually literate, to speak with my images.

And then you had this experience of "learning by fighting" with Alexey Brodovitch in the Design Laboratory of Richard Avedon's studio on 58ᵗʰ Street, just off Park Avenue. This encounter in October 1963 between a Russian aristocrat immigrant, who had come from Paris to become the art director of Harper's Bazaar, *and a Latin New Yorker, educated in a "blackboard jungle school" in El Barrio on the Upper East Side and raised in a building where two boys out of ten survived their Spanish Harlem childhood, seems to have been a real adventure. A New York East Side story meets a European East Side Story.*

I was introduced to Mr. Brodovitch by an old Jew named Dr. Schmidt, who was a friend of Brodovitch's and an amateur photographer. We met while taking pictures of José Greco, the flamenco dancer, when he ran out of film, and I helped him out with several rolls. His way of paying me back was to introduce me to Brodovitch so that I could present my portfolio.

What happened at the Design Laboratory?

Brodovitch, seeing my portfolio and realizing that it was a very amateur portfolio, made the only honest comment he could make: that the photographs were clear and sharp. And for this reason he was giving me a scholarship to Design Laboratory. This meant to me that I was a genius, and that my work was superb. But Brodovitch had a different reason. On the night of the first class I figured that Brodovitch's agenda and mine were going to clash. He had chosen me to be the first to present my portfolio to him and to the students. He gets this real horrible look on his face, and he says: "This is shit. This portfolio's so bad, it should be burned. It's amateurish. It's like a camera club." I realized that Brodovitch was using me as a tool to show his strength.

He was surprised when I called him a son of a bitch and claimed that I would stay for the entire scholarship.

On another occasion you said that Brodovitch was a "pain in the ass," and that the people who were successful with him were those who never had a choice, who realized that they had to be on top or couldn't be there at all. How did you survive this education by pain, this titillating and tantalizing?

That was how I survived life. Being a dyslexic, I only have two choices: to be the boss or the janitor. And I prefer to be the boss. Brodovitch, realizing that I would not go away, decided to test me some more. One night, when he was drunk, he told me to take over the teaching for that night. I had no idea what to do, but I knew that I had to have an opinion. So I preceded all the critiques with those magic words: "In my opinion ..." That night there were many fights and many arguments. When Brodovitch returned, he got a lot of messages about a fire-crackery night. To him, this made me a much more interesting associate. So I followed Avedon, Penn, Hero and Harvey Lloyd as his associate. When Brodovitch left for France, to live in Avignon, he gave me Design Laboratory. And out of Design Laboratory came the Photo-Film Workshop. The Photo-Film Workshop went to the New School, and out of the New School came the photography department of the Parsons School of Design.

Later on, as head of the department of photography at Parsons, you had a number of famous lecturers.

Oh, yes. There were over two hundred. Think of Richard Avedon, Irving Penn, Eugene Smith, Philippe Halsman, Diane Arbus, Lisette Model, Joseph Breitenbach, Art Kane, Aaron Siskind, Eddie Adams, Susan Meiselas, Jill Freedman, Lenard Freed, Arthur Rothstein, Bob Edelman and many others.

One of them is still with you in a very personal way. It is Lisette Model, who was born in Vienna and introduced to music by Schönberg. She discovered photography in Paris and after her immigration became one of the attractions of the art scene of Greenwich Village and the New School.

When Lisette passed away, everybody ran to her apartment to take something. Her lawyer took her equipment, her agent took her negatives and prints. Her sister came with Berenice Abbott and gave the permission to cremate her. Two months later I got a

phone call. Who was to take Lisette Model's ashes? I was the only one to accept them, and I put them in a safe. And today they are like a talisman of good spirit for me in the continuity of photography and education.

What about the relationship between Brodovitch and Avedon?

Avedon recently had a TV show on his life, where he mentions Brodovitch as his father. When Brodovitch introduced me to him, Avedon took me aside to thank me for helping out Brodovitch: "He's important to all of us. And you know, when I got started, he did so much for me." And with that, the old man turns around and says: "You son of a bitch. You elbowed your way into my life." And Avedon looks at me, and he says: "This is my studio! Look at the way he treats me!"

Was this the Brodovitch style of communication?

Brodovitch said: "Never become an assistant, because you'll lose your brains. You'll be my associate, and you'll be my partner." He didn't want me to be a carbon copy of himself. He got great pleasure in putting the fire to people's feet and watching them dance. That was his joy in life, to provoke and evoke a reaction. Brodovitch gave us the initiation, but our character gave us the way to continue. Many came to Brodovitch, but very few continued. Those that did – like Avedon and Penn – relied on their strength, as did I.

Isn't it a sadistic method of educating people?

Yes, it is very sadistic. But that seems to be the Russian way.

Niklas Luhmann says that perception and communication are two separate fields, only integrated in the arts. Do you think the artist is solitary?

He is solitary in his quest for communication of his perceptions. I found that in the Sixties, when I was covering the protest movement, each side wanted me to join in and accept their beliefs. And when I refused, they were angry with me, saying that I was sitting on the fence. When I told them this was my point of view, they never understood.

What about the "decisive moment," the title of Cartier-Bresson's first book? Do you have to be interested or disinterested for it to come and be present?

The immediate assumption is that you have to be interested. But more times than not, the moment presents itself and you respond intuitively. So interest is not of importance. The decisive moment is the moment when you and the object are in sync.

And what about the continuity between these moments? Is there a certain basic mood?

For me, no. If you look at the image with the man in the white suit on a street in Puerto Rico, for example, the moment came while I was eating breakfast. A comment was made about this man; turning my head, I caught him in my eye and jumped immediately over the person who was sitting next to me into the street, dropped low and shot immediately down the center of the street with the man in the left of the image. That decision involved not only the man in the white suit but calculating the composition.

Let's talk about the opposite experience – looking for the pictures you have in mind.

Often I have to previsualize. I have ideas of images I want to get, and then I try to find them, going out into supermarkets or into places where people are. But very seldom does it come together that things are perfect. It is a matter of chance as well. An example of chance is that bicycle shot. Then it happens that I see that a picture is there, but it's only there for a very short time, and there's a statement of Robert Capa's: "If you're not close enough, your picture won't be good enough."

That may suggest an approach to William Klein and his "close-up."

Yes. He is a good friend of mine, and he too uses the wide-angle lens. And the reason why the wide-angle lens is important is that you get close enough that your presence is noticed.

What kind of presence?

The photographer in his body language may be menacing or supportive. Many times the subject has an idea of how to be photographed, and often you will see them closing their eyes and then preparing themselves for the picture. So the question is: Who is the photographer – the subject or the operator of the camera?

Some photographers don't put film into the camera for the first few minutes of a session.

In my case, no. Because I like the interplay between the photographer and the subject. Many times I have this vicarious feeling, identifying the mood of the moment, a feeling that comes from my experiences of stories and of life.

How did you get from Brodovitch, this man of no dreams, to Martin Luther King, who said, "I have a dream"?

On the first of May, 1964, Brodovitch looked out of his window at Union Square, where the Communists and the Cubans and the Neo-Nazis were demonstrating against each other. And he said: "There is your project."

So you came to your socially oriented projects by chance?

Not necessarily. My suspicion is that Brodovitch, noticing my involvement with him, understood that I was socially involved.

132 *Did that happen under the shadow of the McCarthy era?*

It was at the end of the legacy of McCarthy. The beginning of the end was the famous TV interview with Ed Murrow in 1954, and the end of the end was when the students at Berkeley started to demonstrate in 1962-63. This was the beginning of the protest movement and of bringing a broader view into the Civil Rights movement.

And what did you do on May Day 1964, half a year after the assassination of President Kennedy?

I put film in my camera and took the elevator down to Union Square. It took me forty rolls of film to get four good pictures. Five years later, when I concluded the project, it took me four rolls of film to get forty good pictures. I developed my serendipity.

How?

I had covered so many demonstrations that I could predict the formula. And that would lead me to the right location for the manifestation.

Does "formula" mean that there was nothing new?

The early demonstrations were placards, signs and marching. But later on there was an increasing element of organized violence from all sides, and this was the

moment for me to join Martin Luther King and his movement of non-violence.

When was this?

It was on April 15th, 1967, when King marched to the UN in New York and spoke in front of the UN to three-quarters of a million people for the first time about the war in Vietnam being a racist war, when he broke with President Johnson. This was the joining together of the Civil Rights movement of the Fifties and the protest movement of the Sixties.

And how did gregarious Ben Fernandez keep his distance as a photographer for a personal point of view in situations in which masses felt united?

That's a hard question. I believe that when I work I am a different person. I become quiet, observing and trying not to interfere with the moment.

Could you describe one of these artistic moments of non-interference?

There is a picture of the youngest daughter of Martin Luther King seeing her dead father for the first time two days after he had been shot on April 4th, 1968. Knowing the King family, I had put myself into position to photograph this girl instead of her mother. That was my individual position. At that moment she screamed, "Oh, Daddy!"

Did this moment and what followed change your life, too?

Yes, because all of the leaders were being killed – the Kennedys, King and others.

Did it change your work?

Yes, because the demonstrations had changed and become more violent. So I left and started a personal protest movement, investigating and exhibiting mental poverty, which had attracted my interest in 1966.

Did the Guggenheim Fellowship change your work?

No. It gave me an opportunity to work more and to develop a new style.

What style?

Since I had no project, it let me explore my heritage, to tell the story of the "Four Generations" of the

Fernandez family, coming from Spain via Puerto Rico to New York. I think it has been shown in Dortmund, too, in 1986.

That amounted to leaving the political movements and looking for your roots.
 That's it.

Last year you had a stroke. Did it change the rhythm of your life and of your photography?
 Yes. It demonstrated to me that time was no longer on my side, and that projects that were important to me had to be concluded.

Is there still a personal belief on your part – living in these Nineties – in the values that moved the Sixties?
 Yes, I still believe in these values, but with a sadness of belonging to a disappearing minority. And do you know that I laugh when I look at this "hand in hand" of the Sixties in old TV pictures and think of the situation nowadays? The Sixties were a period that only comes once in every five generations. The Bible says it takes three generations to change – and I believe, two generations to learn.

Ralf Dahrendorf says that making a revolution takes six weeks and installing a new infrastructure takes six years, while people need 60 years for a fundamental understanding of the potential new structure. Ben, you have been the teacher of generations of photographers in New York and in your Focus Workshops in Dortmund (at the Fachhochschule), Moscow, Paris, Helsinki, Guadalajara and other places in the world. It's now your 60ᵗʰ birthday, and we congratulate you. What do you think about the future of photography?
 I believe that we are now where painting was a hundred years ago. Because of the computer and digital imaging, the general population will swing away from traditional photography to electronic imaging, leaving the photographer to explore his psyche.

And do you think imagination will survive in the new technologies?
 I hope there will always be imagination.

Biography

Benedict Joseph Fernandez III was born in New York on April 5th, 1936, the son of Benedict Joseph Fernandez II, a Spanish-Puerto Rican shipyard worker, and his Italian mother Palma. He grew up in Spanish Harlem.

After completing high school, where he distinguished himself as a champion swimmer, he found work at an automobile stripping yard.

With the aid of a scholarship from Columbia University he worked to overcome his dyslexia, a reading disorder first identified and treated in the 1950s.

In 1953 his father helped him obtain a job as a steelworker at the Bethlehem Steel factory.

In 1957 he married Siiri, from Estonia, who has since made a name for herself as a fashion designer.

Beginning in 1959 he worked as an operating engineer and crane operator at the Brooklyn Navy Yard.

His son Benedict Joseph Fernandez IV was born in 1958, his daughter Tiina in 1961.

In 1962 Ben Fernandez won his first photo prize, awarded by the Essex County Horse Show of New Jersey, where he had recently moved. As a Puerto Rican, he was not accepted by his new conservative neighbors.

The Navy Yard was forced to close in 1963. Ben Fernandez turned his high-school hobby into a profession and became a full-time photographer. Several of the photos that later attracted worldwide attention were shots taken during the early 1960s at demonstrations he witnessed while returning home from work (Allen Ginsberg's demand for the legalization of hashish).

The decisive moment in his career came in 1963, when Alexey Brodovitch, art director at *Harper's Bazaar,* for whom Ben Fernandez originally worked as a driver, gave him a chance to participate in the Design Laboratory, Brodovitch's class conducted in the studios of famous photographers such as Richard Avedon. After Brodovitch's death in 1971, Ben Fernandez succeeded him and carried on his tradition. He also gave instruction at a number of camera clubs in New York and New England.

With the help of friends, he got a job as a photo lab technician at the New York Parsons School of Design in 1964. There, he combined the many small darkrooms of the individual institutes into a single large laboratory center and soon began instructing again.

In the course of the 1960s Fernandez became a highly sought-after photojournalist. Through his agents Nancy Palmer and Ursula Mahony he obtained assignments from the *New York Times Magazine, Newsweek, Paris Match,* the *Toronto Star, Canadian Broadcasting* and *Look.* Major milestones in his career were the publication on June 2nd, 1966 of his photograph of five men burning their draft cards in protest against the war in Vietnam and the appearance of a Fernandez photo on the first color cover page of the *New York Times Magazine* on June 6th, 1966.

In 1967/68 he was a member of Magnum, the well-known photo agency. His position of strength at the Parsons School led to the termination of his contract in 1970. A student strike on his behalf forced the school to reverse its decision, however.

In 1971 he was appointed chairman of the New School, which was taken over in the same year by the Parsons School, making him chairman of the Parsons School as well, a position he held until 1992.

In 1974 he succeeded in establishing the photography program as an independent department, which began awarding degrees in 1979.

He founded the Focus photography workshop in 1979, providing students the opportunity to participate in international exchanges. First contact with Dortmund was established in 1981. Later exchanges were set up with Mexico (1987), Moscow (1988), Finland (1989) and Paris (1995). Focus remains an ongoing program in all of these cities. Competitions are part of the Focus program at some locations, the winners of which are likely to be among the leading photographers of the younger generation.

In 1981 Ben Fernandez established the Leica Medal of Excellence. Originally intended as a prize for the best photo book publication of the year, its purpose was to enhance the library collection at the Parsons School. Today the prize is awarded by Leica itself.

Strongly committed to teaching, Ben Fernandez was often unable to pursue his own career in journalism. In order to escape the daily educational routine, he frequently traveled abroad on fellowships to do independent work of his own. He received the J. Salomon Guggenheim Fellowship in 1969/70, the National Endowment for the Humanities Fellowship in 1972/73, the National Academy for Arts and Sciences Fellowship in 1986 and a Fulbright Scholarship for Paris in 1992/93.

Today, Ben Fernandez continues to teach at the Parsons School in New York. He has also returned to photojournalism and is now engaged in collating and cataloguing some 7,000 black-and-white negatives and an equal number of color negatives in his own collection. His own motto is an eloquent expression of his strength and vigor: "I would like to continue growing."

Selected Solo Exhibitions

1966	*Social Protest,* Parsons School of Design, New York (1969 Art Institute of Chicago, Illinois; 1972 Davison Art Center, California; 1981 Southampton University Gallery of Photography, New York; 1982 Daytona Beach Community College, Florida)
1969	*Puerto Rico,* Boston Museum of Fine Arts, Boston, Massachusetts
1969	*Sports Cars,* Leica Gallery, New York
1969	*Conscience: The Ultimate Weapon,* George Eastman House, Rochester, New York (1967–70 Public Theater, New York; 1981 Arles Festival, Arles)
1967–70	*Color Photographs of Public Theater Productions,* Public Theater, New York
1967–70	*In Opposition,* Public Theater, New York
1971	*Machismo: Puerto Rican Men,* Institute of Culture, Puerto Rico
1971	*Retrospective,* Academy of Music, Brooklyn, New York
1975	*Hoboken,* Stevens Institute, Hoboken, New Jersey
1977	*Four Generations,* Museum of the City of New York, New York
1979	*Retrospective,* Parsons School of Design, New York
1980	*Bethlehem Steel in Hoboken,* Newark Museum, Newark, New Jersey

1980	*Machismo,* Lima, Peru
1980	*Performance,* Arles Festival, Arles
1981	*Speaker's Corner,* New School for Social Research Art Center Gallery, New York
1981	*Bullfight,* Monmouth Museum, New Jersey (1983 Brookdale Community College, New Jersey)
1984	*Mental Poverty,* Isalmi, Finland
1985	*Reflections of American Society,* New School for Social Research Art Center Gallery, New York
1986	*Mothers of Exile,* Parsons Exhibition Center, New York; Liberty Island State Park, New York
1987	*Men in America,* Pentax Gallery, Tokyo
1989	*Bikers,* Soho Photo Gallery, New York; 20/20 Photography Gallery, New York
1990	*Martin Luther King: Countdown to Eternity,* Forbes Magazine Galleries, New York; Schomburg Center for Research in Black Culture, New York
1991	*Martin Luther King: Countdown to Eternity,* Museum of Fine Arts, Houston, Texas; Embassy of the United States, Moscow; Fondation France-Amérique, Paris; University of Tallinn, Estonia; University of Industrial Arts, Helsinki
1992–94	*Martin Luther King: Countdown to Eternity,* traveled to 18 cities across the United States under sponsorship of the Ford Foundation and the Manchester Craftsmen's Gild; traveled through 27 African countries under sponsorship of the United States Information Agency.
1994	*The Last Campaign,* The Leica Gallery, New York
1995	*Men,* Manchester Craftsmen's Gild, Pittsburgh, Pennsylvania
1995	*Martin Luther King: Countdown to Eternity,* Corcoran Gallery of Art, Washington, D.C.; George Eastman House, Rochester, New York; Capitol Rotunda, Indiana

Selected Group Exhibitions

1970–73	Museum of Modern Art, New York
1974	Huntington Hartford Gallery of Modern Art, New York
1974	Neikrug Gallery, New York
1981	Trenton Museum, Evidence, New Jersey
1982	*Brodovitch Memorial Exhibition,* Paris
1982	*Brodovitch Memorial Exhibition,* Arles Festival, Arles
1991	*Martin Luther King and the Civil Rights Movement,* Museum of Fine Arts, Houston, Texas

Ben Fernandez is a member of the following organizations and professional associations:

since 1968	Committee of the Alexey Brodovitch Design Laboratory
1970–71	Committee CAPS
1970–73	New York State Council on the Arts
since 1974	Board of Advisors, International Center of Photography, New York
since 1975	Massachusetts Council on the Arts, Boston
since 1978	Board of Advisors, Catskill Center for Photography, State of New York
since 1980	Board of Advisors, W. Eugene Smith Memorial Fund, New York
since 1983	Education Committee of the American Society of Magazine Photographers, New York
since 1987	Kodak Advisory Council

Permanent Collections:
Le Mémorial – Un Musée pour la Paix, Caen
Museum of Modern Art, New York
Boston Museum of Fine Arts, Boston
International Center of Photography, New York
Smithsonian Institution, Washington, D.C.
Davison Art Center, California
Martin Luther King Memorial Library
Museum of the City of New York, New York
Bibliothèque Nationale, Paris
Arles Festival Collection, Arles
Museum für Kunst und Kulturgeschichte der Stadt Dortmund
Private collections

Bibliography

In Opposition. Images of American Dissent in the Sixties, by Benedict J. Fernandez, Preface by Aryeh Neier (New York: 1968).
Trumpets of Freedom. Martin Luther King (Toronto: 1968).
Countdown to Eternity. Dr. Martin Luther King, Jr., Photographs by Benedict J. Fernandez, Pittsburgh undated
Four Generations. The Odyssee of the Fernandez Family, Benedict Joseph Fernandez, Institute of Contemporary Hispanic Art (New York: 1977).
Mothers of Exile. Refugees imprisoned in America, Lawyers Committee for Human Rights, Helsinki Watch (New York: 1986).

135

Periodicals

Steinorth, Karl, "Die Kamera als Waffe? Die Kamera – ein Weg zu Einsichten und ein Ausweg." Review of *In Opposition* in *Retina, Kodak Revue für Foto und Film,* Vol. 19, No. 2, 1970, pp. 62–64.
Poli, Kenneth, "Photography as a fourth ‹R›. A panel of prominent experts consider the case for teaching photography to your child in grade school" in *Popular Photography,* August 1974.
Schaub, George, "Activity and Awareness: A Profile of Benedict J. Fernandez III" in *Photographers Forum,* May 1983, pp. 25–33.
Jay, Bill, "Snaps. Rediscovering the magic of photography" in *Popular Photography,* Annual 1984, p. 7.
Livingston, Kathryn, "Ben Fernandez. A well known teacher talks about the future of photo education and the merits of experience" in *American Photography,* Vol. 5, 1985, pp. 74–80.
Kenan, Naomi, "Photos bring Fernandez back to his roots" in *Visual Art,* pp. 3–5, Ill. 28–29.
Seidel, Mitchell, "Touches of absurd add to visual commentaries" in *Photography.*

Portfolio Editions

Countdown to Eternity. Photographs of Dr. Martin Luther King, Jr., In the 1960's by Ben Fernandez. A limited portfolio edition of prints (Rochester, New York: 1989).

This publication is the official catalogue for the exhibition entitled
Benedict J. Fernandez – I AM A MAN at the Museum für Kunst
und Kulturgeschichte der Stadt Dortmund from June 15 to July 28 1996.
Director: Wolfgang E. Weick

MUSEUM
für Kunst und Kulturgeschichte
DER STADT DORTMUND

Amerika Haus in Cologne as a part of the Kodak culture program
and Photokina, Cologne from September 12 to October 18, 1996.

Leica Gallery, New York 1997.

For their confidence and support Ben Fernandez wishes to thank:

Michael Z. Engl, Engl Trust
Raymond H. de Moulin, formerly of Eastman Kodak
The employees of Leica, USA

Editor: Brigitte Buberl
Translations from the German by John S. Southard
Texts edited by Esther Oehrli and Ralph Schneider
Art direction and typography by Peter Renn · Typografie,
Teufen, Switzerland
Photolithography by Colorlito Rigogliosi S.r.l., Milan, Italy
Printed and bound by EBS Editoriale Bortolazzi-Stei s.r.l.,
San Giovanni Lupatoto (Verona), Italy

ISBN 3-908162-35-1